The Simple Art of Celtic Calligraphy

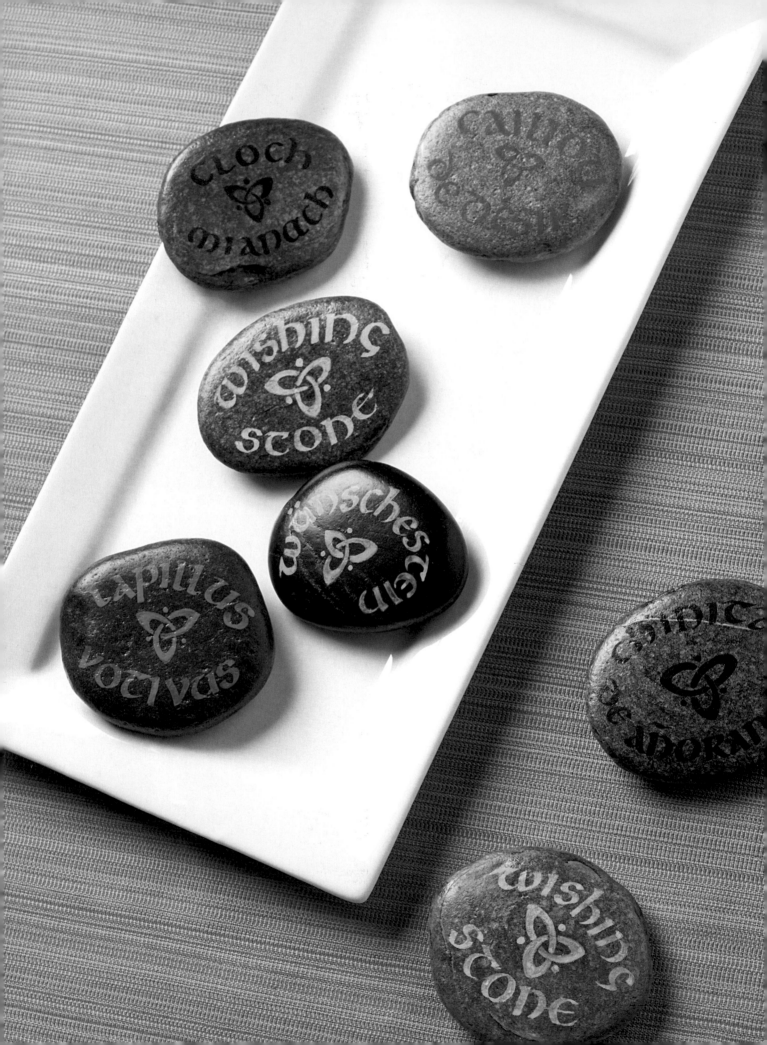

The Simple Art of Celtic Calligraphy

20 step-by-step projects and essential techniques

Fiona Graham-Flynn

CICO BOOKS

LONDON NEW YORK

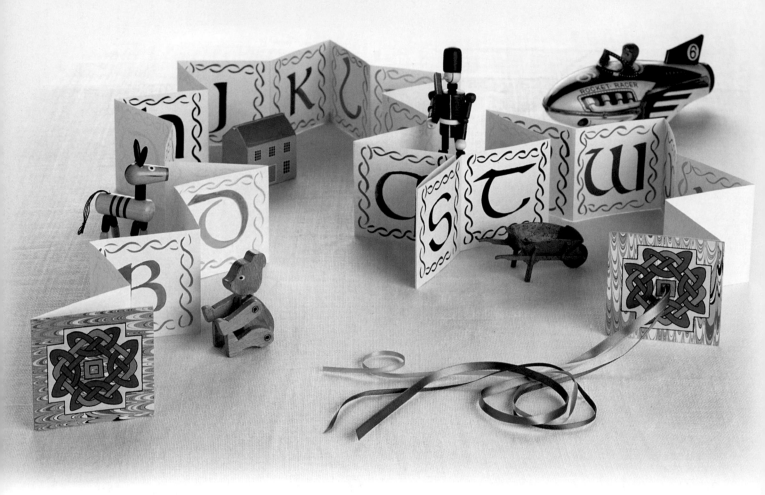

Published in 2008 by CICO Books
an imprint of Ryland Peters & Small
519 Broadway, 5th Floor, New York, NY 10012

www.cicobooks.co.uk

10 9 8 7 6 5 4 3 2 1

A CIP catalog record for this book is available
from the Library of Congress

ISBN-13: 978 1 906094 91 1

Printed in China

Editor: Robin Gurdon
Designer: Ian Midson
Photographer: Geoff Dann

Contents

Introduction

The beauty of Celtic calligraphy was captured in the great manuscript works of the Middle Ages. With this book, you can learn to create your own pieces of art, inspired by works such as the majestic Books of Kells.

The ancient art of calligraphy evolved into the form we recognize today, the Uncial script, with the Roman writing of their majuscule, or capital, letters. The English and Irish style of majuscule letters, known as Insular style, that developed into the Uncial alphabet was first seen in the sixth and seventh centuries. By the eighth century it had been joined by the miniscule, or lower-case, letters of the Half-uncial alphabet with their characteristic rounded form.

A modern rendering of the Cross of Enniaun

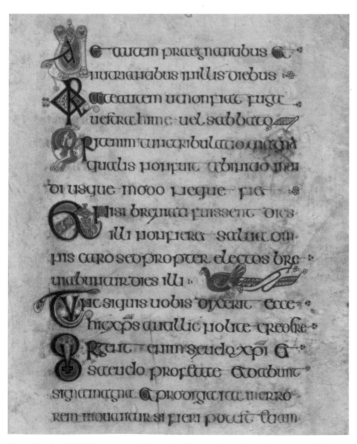

The Book of Kells was written in the early ninth century. This page of beautiful Half-uncial script is decorated with illuminated letters and stunning zoomorphic details.

In these early centuries, all writing of note was created by monks known as scribes. Living in monasteries across northern England, Scotland, and Ireland, it was their job to create the holy books used by the early Christian Church in the centuries before the advent of printing. One such monastery was located on the remote island now known as Holy Island, just off the Northumbrian coast of England. It is here in the eighth century that the great work known as the Lindisfarne Gospels was written, using an Uncial script with large illuminated pages of vivid color.

The tiny Scottish island of Iona, founded by the Irish monk St Columba, was to become the birthplace of more acclaimed manuscripts in the ninth century. Here the famous Book of Kells, also a set of the four Gospels, was inscribed. Ireland, too, has produced beautiful manuscripts such as the Book of Durrow and Armagh.

Born in Scotland and now living in England, I have been a calligrapher for 28 years and have always been drawn back to the calligraphy and art inspired by those amazing Celtic scribes. The scripts were written with a quill pen cut from the flight feathers of a goose or swan, not on paper but on vellum which was made from calf skin. Every scribe had a unique writing hand, and their personality can sometimes be seen in the little notes that they left in the margins of the pages—how they were tired of writing or how their hands were cold. Parts of these books were decorated with what are known as carpet pages. Where pages had no text they were instead covered with patterns and shapes designed with spirals, interlacing knotwork, key patterns, and beautiful color work.

The manuscript books were written in different ways. Sometimes one scribe alone would write and illustrate the pages throughout a whole book in what could turn out to

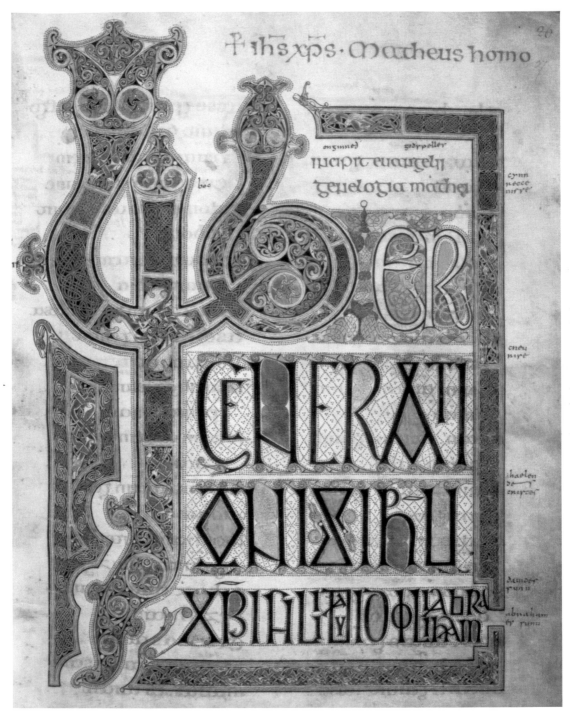

Written in the north of England, a century before the Book of Kells,
the Lindisfarne Gospels included illuminated pages of cursive capitals
decorated with intricate, vividly colored designs.

be a lifetime's work. In other books, one scribe skilled in calligraphy would write the text, passing it on to another monk who would illuminate and embellish the pages with colored pigments.

This book will endeavor to feed your imagination with 20 simple inventive projects. You will be amazed at what you can achieve using the step-by-step instructions and easy-to-follow pictures. Once finished, each project can be kept or can be given as presents to friends, family, children, and grandchildren.

Enjoy the challenge and have fun mastering the art of Celtic calligraphy!

MATERIALS

Although a calligrapher's array of equipment can look daunting, you can start with just a single pen, some black calligraphy ink, and plain cartridge paper. As you become more practiced, enjoy finding those new materials that will enhance your calligraphy.

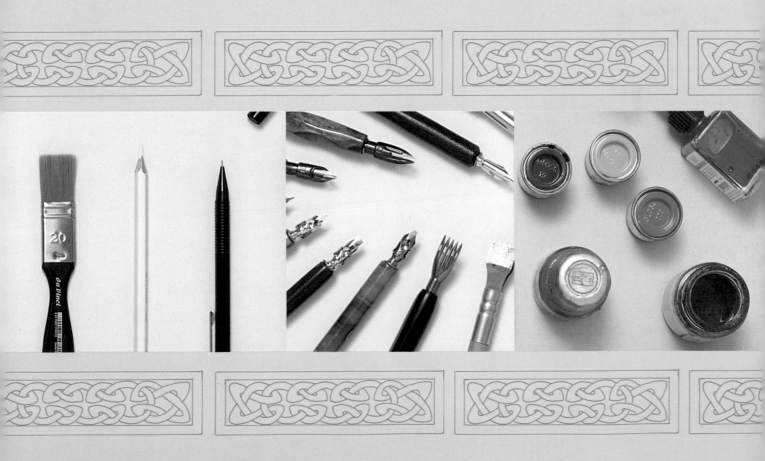

Materials

The beauty of calligraphy can only be properly appreciated if it is created with the right materials. The pens and nibs must allow the letters to be written smoothly and crisply, paper needs to be beautiful to touch and not smudge carefully crafted wording, inks should be deep, black, and true, and brushes must be fine enough to allow the finest decoration to be added. Start with a few basic pieces and gradually build up your collection of materials as your calligraphy improves.

The basic materials you will need to start practicing calligraphy are paper, pens, and inks. As well as these, you should also have a supply of tracing paper, some soft and hard pencils, a ruler, an eraser, and a fine-line black pen. Most important of all, though, is to ensure you have a comfortable, even drawing board at which to work. Once you have these writing tools, you can begin to explore different types in order to discover which ones you prefer to use.

Papers

There are many calligraphy papers available, the best being smooth paper called "hot-pressed" which will take the ink very well. Vegetable parchment papers can also be used, and they come in a range of colors, from white through dark tones.

Watercolor and canson papers and thin card can be white through deep shades and they give an attractive textured look to the writing. Handmade papers are another option, although some can be porous, which makes it more difficult to write on them smoothly.

More exotic papers include goatskin parchment paper which comes in two weights and is sold in ivory and cream colors. It has a smooth surface and is watermarked. Vellum and parchment hides are suitable for special projects as they not only look beautiful, but have a lovely feel when writing and mistakes can be easily scraped away.

Pens

A pen holder that can take many different nibs is the most common calligraphy tool. They can be made from natural wood, decorative color-coated wood, and plastic.

The most suitable nib is the straight chisel end. Coming in a variety of sizes, the Speedball style C—the most widely available—is referred to throughout this book. All nibs need to be combined with a brass ink reservoir. Left-handed oblique nibs are available, too.

There are other nibs available that give different decorative writing strokes including pointed and double-ended. Multi-point nibs replicate 5 writing lines for every letter, giving an intricate effect. There are also automatic pens where the nib and holder are in one; these tend to be larger in size and need to be filled with ink with a brush.

A great addition to your pen collection is a fine point black pen. A draughtsman's drawing pen can be bought in variously sized points, making it the best tool for all fine-line work. Metallic gold and silver pens of different point thicknesses are an equally good acquisition.

Brushes

Of the many brushes available, the best for illumination work are red sable brushes. They come in various sizes—the 000, 0, and 1 are the most useful for this type of painting when a fine brush is needed. There

Ideally, a studio should have plenty of natural light and lots of storage space for inks, paper, and brushes, like mine does. My collection of ink wells sits on the shelf by the radio.

are synthetic brushes, too, but they do not hold the paint in the bristles as well as sable brushes and they are not as flexible when applying the color.

A size 3 or 4 nylon brush is fine for mixing paint and applying gouache paint to the nib.

Inks and colours

Inks play an important part in writing calligraphy. Black ink is the most commonly used ink. Chinese black ink is ideal as it is dense, black, and retains a good consistency. Of the rest, waterproof colored inks offer a more delicate look, since they are usually thin and translucent. Pearlized inks appear metallic and come in a variety of colors, but they need to be constantly stirred while being used, as the metallic part of the liquid sinks to the bottom of the pot.

Gouache paint is an excellent medium to use, since it comes in many colors and can be mixed to produce many more. To bind the color, use it with a drop of liquid gum arabic and water.

Papers

Take care to work on suitable paper that shows off your calligraphy at its best. Some make the ink spread or soak it up dulling the quality of your writing, while others can show off the precision and clarity of a piece of calligraphy. As well as watercolor and hot-pressed papers, have a supply of practice paper, tracing paper, and even pieces of vellum and parchment for those very special projects.

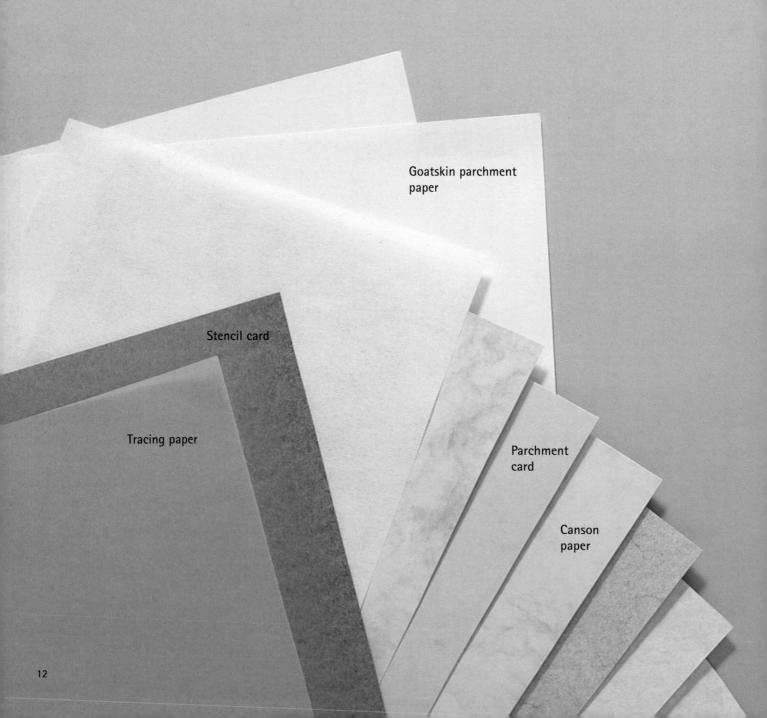

Goatskin parchment paper

Stencil card

Tracing paper

Parchment card

Canson paper

Cartridge paper

Colored
textured
paper

Hot-pressed
colored papers

Goatskin parchment

Vellum

Pens and Brushes

Using the calligrapher's pen, with its assorted nibs and reservoirs, the artist can create an incredible array of scripts and alphabets. Adding just a paintbrush, a fine-line black pen, and a pencil ensures there is no writing that cannot be created.

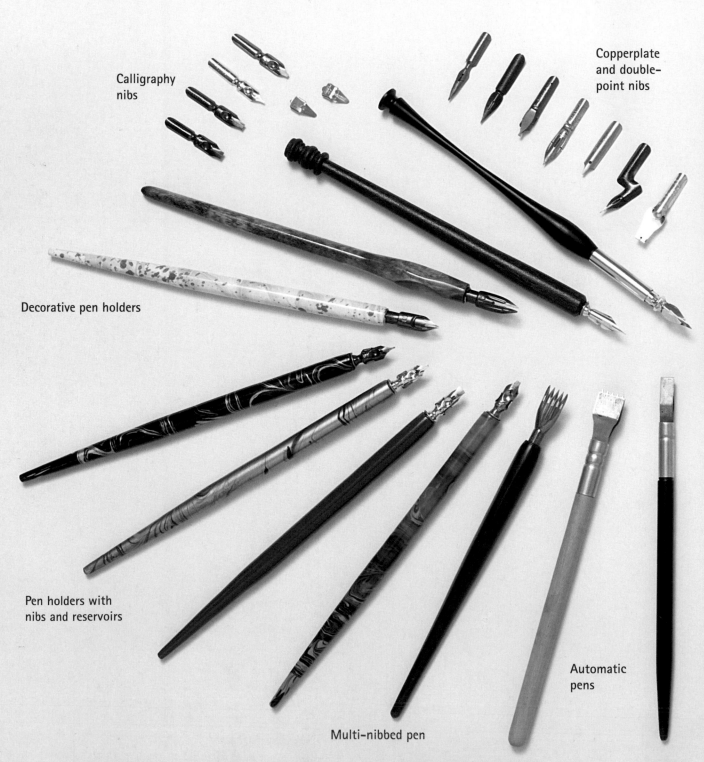

Calligraphy nibs

Copperplate and double-point nibs

Decorative pen holders

Pen holders with nibs and reservoirs

Automatic pens

Multi-nibbed pen

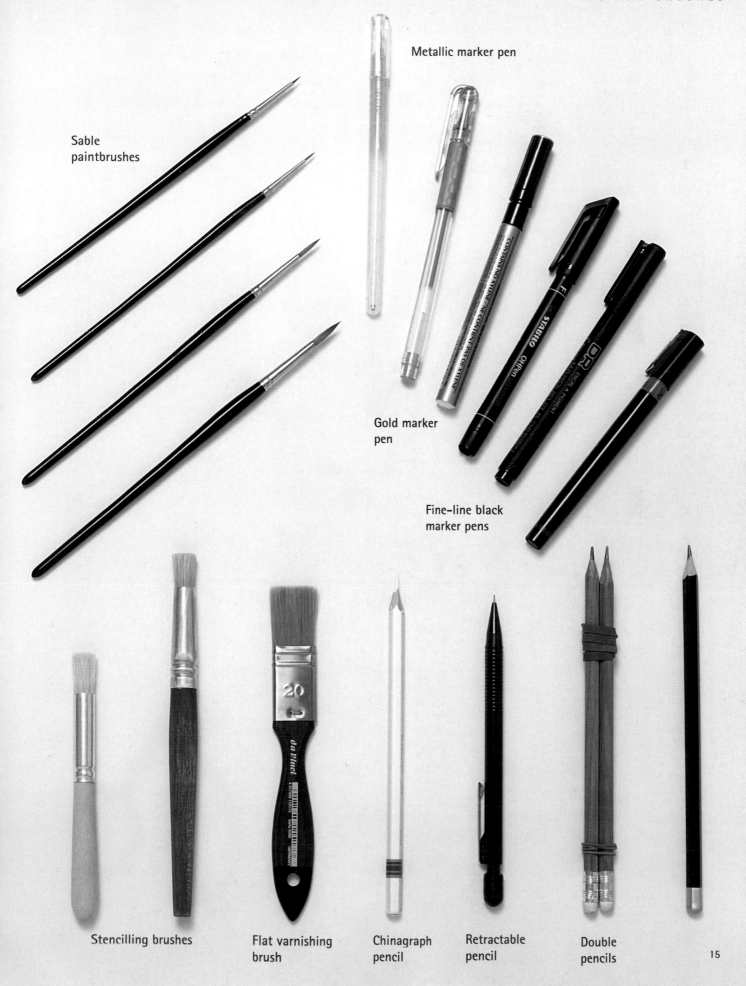

Sable
paintbrushes

Metallic marker pen

Gold marker
pen

Fine-line black
marker pens

Stencilling brushes

Flat varnishing
brush

Chinagraph
pencil

Retractable
pencil

Double
pencils

Inks and Colors

The inks and colors create the textures of calligraphy. Starting with traditional black ink add colored, metallic, and even pearlized inks to your collection as well as gouache and enamel colors. Don't forget all the extra tools to make your calligraphy a success, from scissors and a ruler through to specialist items like the flexible curve.

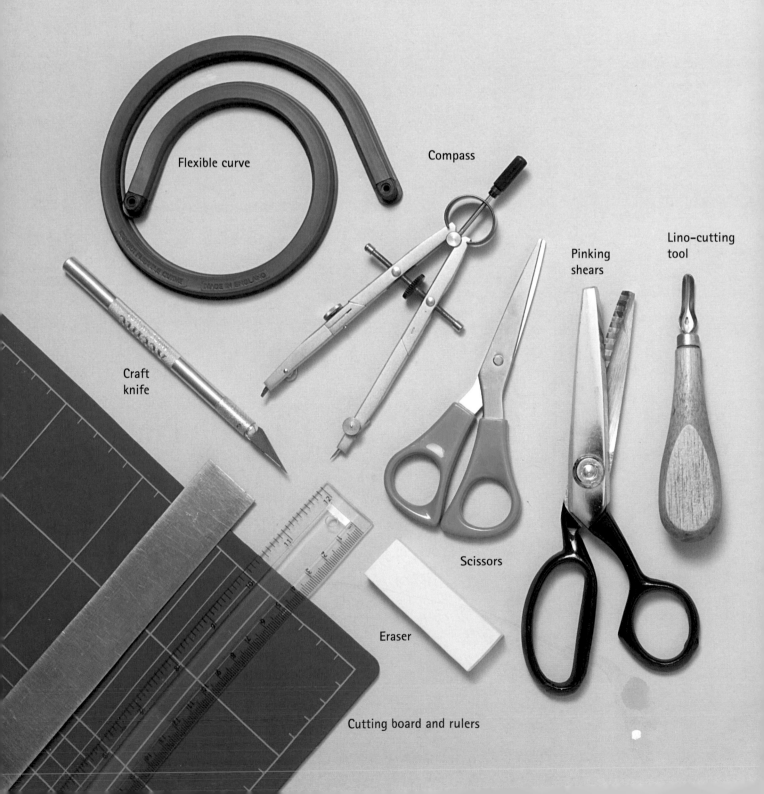

Flexible curve

Compass

Pinking shears

Lino-cutting tool

Craft knife

Scissors

Eraser

Cutting board and rulers

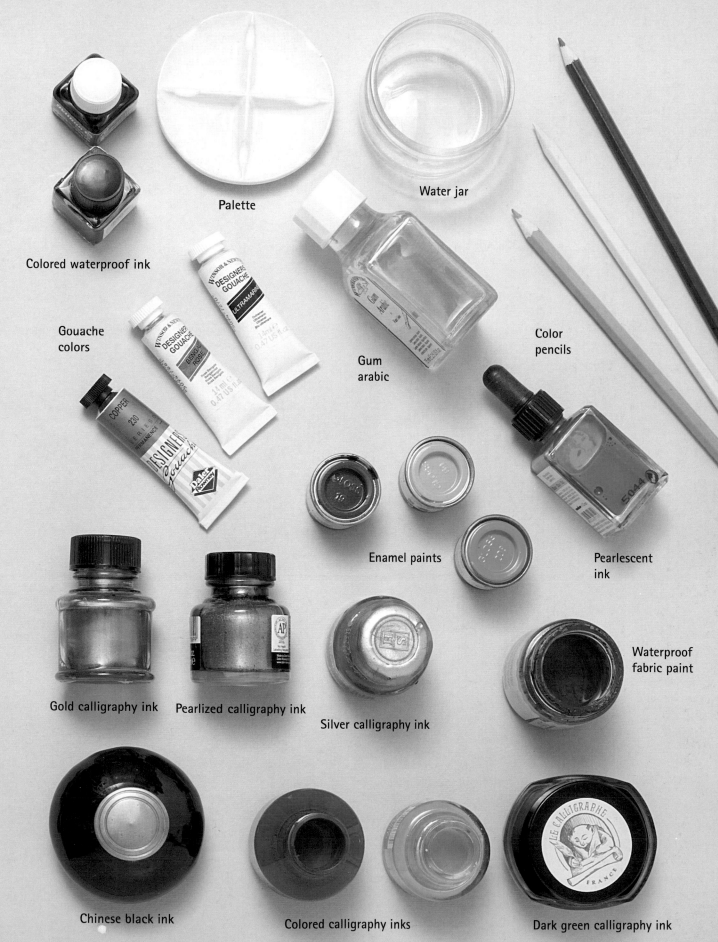

Water jar

Palette

Colored waterproof ink

Gouache colors

Gum arabic

Color pencils

Enamel paints

Pearlescent ink

Gold calligraphy ink

Pearlized calligraphy ink

Silver calligraphy ink

Waterproof fabric paint

Chinese black ink

Colored calligraphy inks

Dark green calligraphy ink

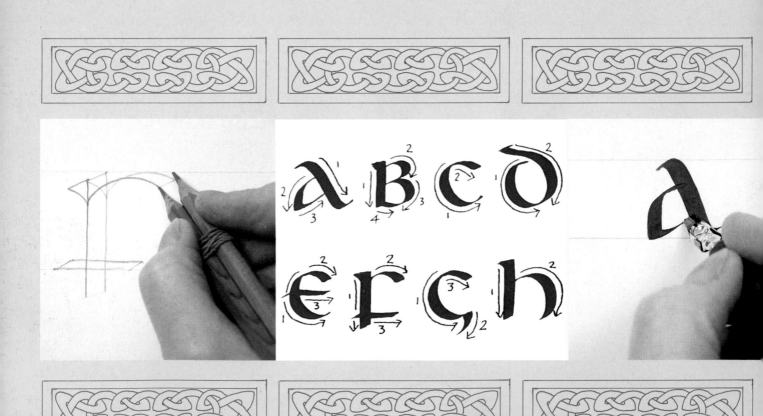

TECHNIQUES

Learn how to write the classic Celtic Uncial and Half-uncial scripts, first in pencil and then with a pen and ink. Practice the letter forms and check your progress against a range of the commonest mistakes before also learning how to draw decorated capital letters and even the ancient runic alphabet.

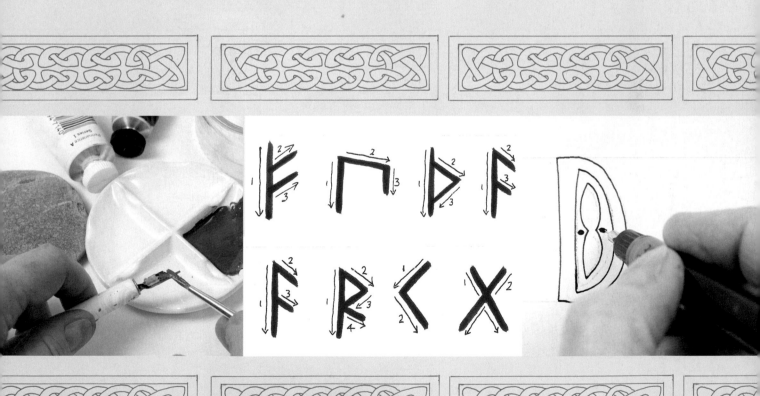

Basic Techniques

When writing Celtic scripts you are aiming to give the letters a rounded appearance and keep the weight of the letter even by holding the pen nib at a constant angle to the writing line. Try to keep lines straight and curves unbroken and even.

Preparing and loading the pen

Because the calligraphy pen has no cartridge or ink container it must be dipped in ink regularly to fill the reservoir (right). Place a nib in the end of the pen holder with firm pressure until it is secure. Attach the reservoir by sliding it onto the underside of the nib, pushing it down the nib shaft. It is important to be able to see the end of the nib a little. Do not have the reservoir too far back or too far forward.

1 To load the pen, first hold the pen in an upright position and dip about half of the nib into the ink. If you fill the nib's reservoir with too much ink it will overflow and flood the paper when you try to write.

2 Remove any excess ink by shaking the pen downward so that the ink falls back into the ink pot. You can also wipe the nib on the side of the ink pot just to be sure.

Holding the pen

It is vital that the pen sits easily in your hand and that you never feel strained or tired while writing—the more comfortable you are, the better your calligraphy.

Hold the pen between your thumb and forefinger about 1in above the nib. Take a firm grip but try to relax your hand and arm from the shoulder. Keep sitting upright with the paper straight in front of you. Ideally the paper should be placed on a board set at an angle of about 45 to 60 degrees.

For left-handed calligraphers the writing position is a little different. Find the most comfortable position by angling the paper either to the right or the left.

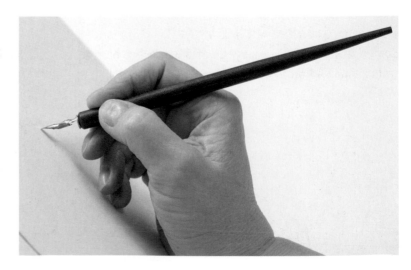

Drawing a pencil stave

The Celtic alphabets look best when the letters are written to a height four and a half times the width of the nib being used. Always draw up a writing stave before you begin so that your letters fit within the guide.

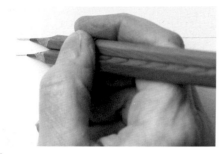

1 Draw a line across the paper then start measuring the distance down using a set of double pencils—the distance between the points equates to the width of a nib.

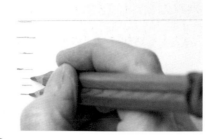

2 The distance between the lines should be 4½ pen widths so mark four spaces from the top line and then add the extra half width at the bottom.

3 Draw the bottom, or writing, line across from this mark. All your writing should be between these lines except for the ascenders and descenders—the tails of letters like "b" and "p".

Placing the pen on the stave

It is easiest to start writing the Celtic scripts holding the nib at a 30 degree angle to the paper. Keep a firm grip on the pen holder but try to relax your hand and arm to the shoulder. This will help with your writing.

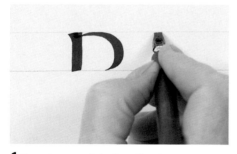

1 To write a straight line, like the upright of the letter "n," place the nib against the top line at an almost flat angle then draw it straight down in a smooth movement.

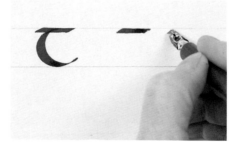

2 To draw a horizontal crossing stroke turn the nib so that is at an angle of about 30°. Turn your hand from the shoulder—don't change your grip on the pen.

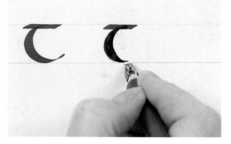

3 To write a curved line, like the bowl of the letter "t," return the nib to a flat angle. Make the stroke in one smooth movement to increase then decrease the width of the stroke.

Loading the pen with a brush

Sometimes you will be using tubes of gouache color rather than calligraphy ink. This works just as well as the ink but must be applied directly to the back of the nib with a paintbrush.

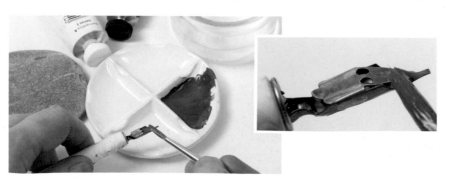

Mix a little of the color in a palette and use a size 3 brush to paint the color onto the back of the nib so that it collects in the ink reservoir. Apply the paint carefully so that the nib does not get overloaded and do not try to fill the reservoir directly: let the paint flow down into it from the bottom of the nib.

Uncial

The Uncial alphabet is the most recognized of the Celtic scripts. It has a pleasing formation, with an open, rounded look including long strokes on some letters while others, like the D, include what is known as a fish tail. It has no capital letters as such.

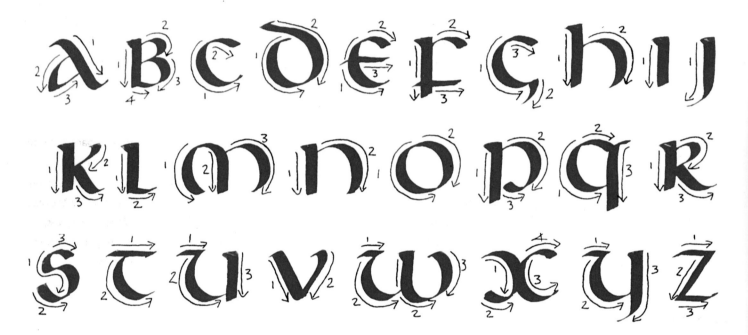

DOUBLE PENCILS

Learning to write Celtic letters with double pencils shows you how they are formed and made up from a series of different strokes. Drawn large on the paper, you will be able to see your progress easily.

Bind two HB pencils together with elastic bands, pushing the points of the pencils together against a flat surface to make sure both are level. Always keep the pencils at the same flat angle to give the letters the right formation.

Writing the letter 0

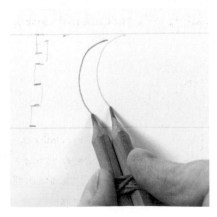

1 Draw a stave of 4½ pen widths using your double pencils. Start with the right-hand pencil touching the top line with the left-hand pencil at a slight angle. Draw the bowl of the letter in a smooth curve. Watch the width change as you write.

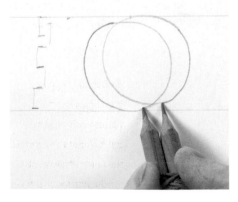

2 Take the pencils back up to the starting point and write the right-hand curve. Finish by joining up with the first curve. As you practice you will soon get the hang of joining up the different parts, creating evenly shaped letters.

Writing the letter A

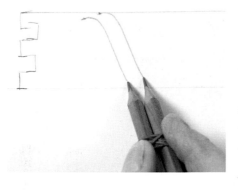

1 Even though the A includes a straight element, start with the pencils in exactly the same position as with the letter O, then bring them down to the right in a diagonal line.

2 Move halfway back up the letter and place the pencils back on the lines but this time move to the left in a slow, downward curve.

3 When the left-hand pencil reaches the writing line turn to the right sharply.

4 Move back up to join the straight line, curving upwards as you near it so that the lines of the pencils cross, creating movement in the letter.

Writing the letter F

1 More complicated letters are simply made up of the same elements. The basis of the F is a straight vertical stroke that descends below the writing line.

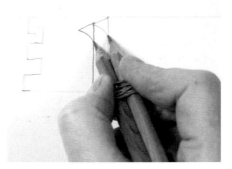

2 Add a decorative serif to the top with a straight diagonal movement to the left followed by a curve back to the right, finishing on the vertical lines.

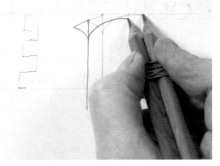

3 To make the top horizontal, curve up from the end of the decoration until you hit the top writing line, letting the pencil lines cross.

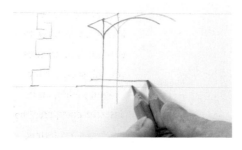

4 The middle line is drawn along the bottom writing line, remembering to increase the angle of the pencils for the horizontal stroke.

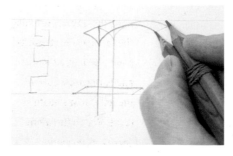

5 Finish by closing up the letter with single pencil strokes across all the openings.

Writing the letter R

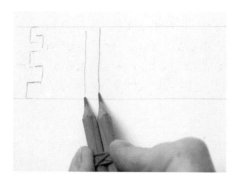

1 As with the F, start by writing a pair of vertical lines, finishing on the writing line.

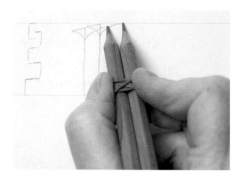

2 Add a decoration to the top and then make a sharp rising movement to the top line.

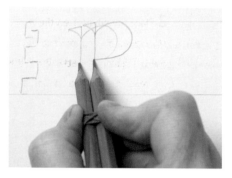

3 Make a smooth but quick downward turn back to the verticals to form the bowl of the letter.

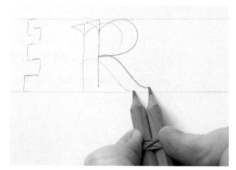

4 Now move down and out to the writing line, giving the leg of the letter a smooth sweep and finishing just to the right of the bowl.

Writing the letter X

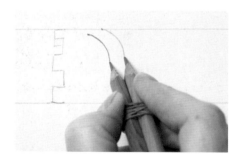

1 Combining curves in a letter can be complicated. The X is especially tricky as the curves intersect. Start making the left-hand curve with the pencils on the top line.

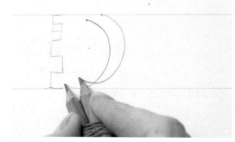

2 Continue until you reach the writing line, moving past it and back up slightly.

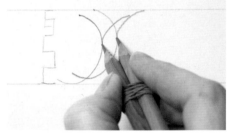

3 Taking the pencils back up to the top line, sweep down in the opposite direction, completely covering the previous stroke.

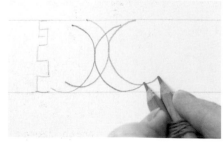

4 Finish the curve as the pencil lines cross each other.

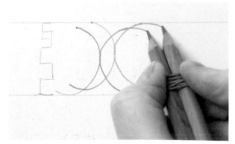

5 Return to the top and continue the curve, stopping in line with the bottom of the letter.

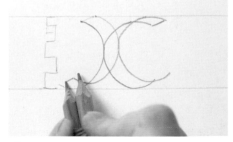

6 Finally, close up the gaps between the pencil lines.

WRITING IN INK

When starting to write in ink the most important factor is to keep the nib at the same angle throughout the formation of each letter. By keeping a flat angle to the paper you will form well-rounded letters whose weight, or stroke thickness, will also be correct—neither too thin nor too thick.

Some letters do require a slight change of angle when writing certain strokes. This is most common when you flatten the nib angle to write the horizontal strokes of the letters F and T. It can also stop the letters V, Y, and Z looking too heavy.

Writing the letter O

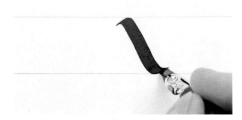

1 Follow the method you used when writing with the pencils, using the ends of the nib as the two pencil points. Start with the nib point on the top line. Draw the nib round to the left, keeping the nib angle constant.

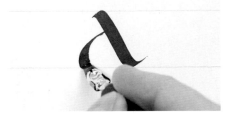

2 Place the nib back on the starting points and move to the right, finishing the letter when the nib touches the end points of the first stroke.

Writing the letter A

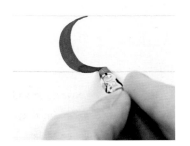

1 Replicate the pencil strokes with the pen and nib. Start at the top line and draw a smooth stroke with slight movements at either end to create the flicks.

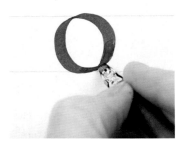

2 With the nib against the first stroke begin the bowl of the letter, keeping the angle of the pen the same throughout.

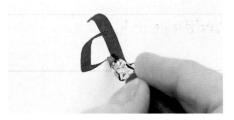

3 Finish by the upright stroke. The nib angle should make the line thinnest as it approaches the end of the stroke.

Writing the letter M

1 The letter M is made up from a series of curves that, at first, can be tricky to combine. Begin with the left-hand down stroke.

2 Return to the top of the letter and finish the top curve, moving into a straight vertical stroke down to the writing line.

3 Write the final stroke in one go, making a slight curve up to the top line before moving down in a gentle curve.

NUMERALS

Numerals are relatively simple to master—yet the important skills here are scale and consistent style, so when writing letters and numbers together as part of the same project, the numbers match the style of your lettering. Practice the numbers as below, following the arrows to see the directions of each stroke. Common mistakes (see right) will help you avoid common pitfalls with positioning and shape for both letters and numerals.

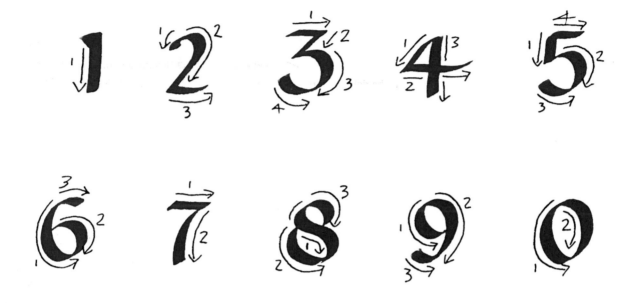

Writing the number 3

1 Write a horizontal line underneath the top writing line.

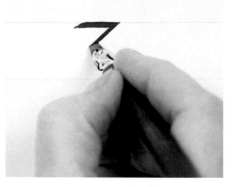

2 Move straight into the short diagonal line, keeping the nib angle the same.

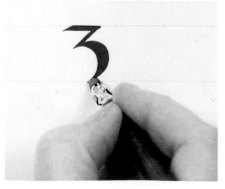

3 Write the curve, sweeping down to hit the writing line in the middle of the numeral.

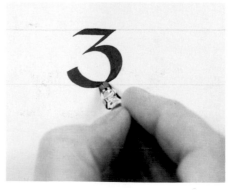

4 Move the nib out to the edge of the horizontal line and make a stroke back to meet the bowl of the numeral at the bottom.

Writing the number 6

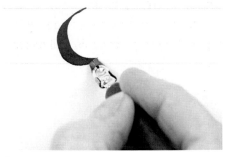

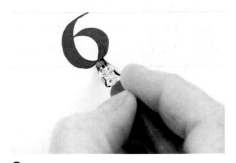

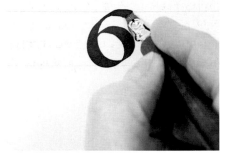

1 Start writing the 6 with the same stroke as the letter O.

2 Place the nib halfway down and draw a curve to the right in a smooth stroke.

3 Returning to the top of the numeral draw a curve over the bowl to finish.

Writing the number 8

1 Write the central spine first, making an S-shaped curve between the writing lines.

2 Enclose the top loop first making a rounded bowl.

3 Balance the numeral by making the lower bowl slightly larger than the top one.

Common Mistakes

This ascender rises too high above the line

Write only 1½ pen widths above the top line and add movement to the bowl with an extra stroke

The shorter descender is more balanced

This descender drops too far below the line

Strokes do not overlap

Keep the nib at a flat angle to balance the three strokes

The two strokes cover each other

The diagonal is too thin and the horizontals too thick

Half-uncial

Sometimes called the Irish Half-uncial script, this was the style used in the great Irish manuscripts such as the Book of Kells. Developed around the eighth century, it bears many similarities to the slightly earlier Uncial alphabet, with its open, rounded forms. It is pleasing to the eye, and its simplicity makes it easily read.

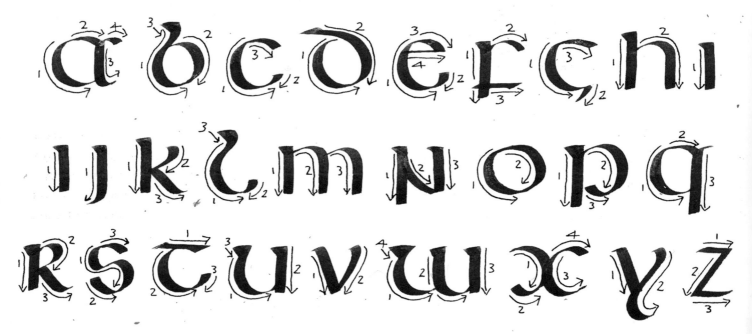

PRACTICING WITH DOUBLE PENCILS

Although the Half-uncial alphabet has many similarities to the Uncial script it is important to practice writing the letters with pencils first to become familiar with the different letter forms.

Writing the letter A

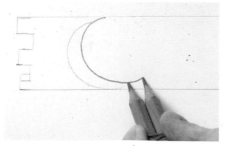

1 Begin making a wide, sweeping curve stroke with the double pencils. When the bottom pencil hits the writing line move back up and stop.

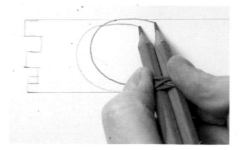

2 Finish the curve at the top by bringing the lines across to the right and down so that they end up in line with the bottom stroke.

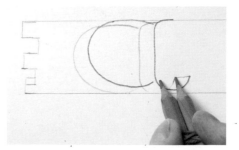

3 Start the vertical stroke just to the right of the previous stroke and bring it back toward the bowl of the letter before going straight down. Finish with a pronounced curve, and close up the gap with a single stroke.

Writing the letter N

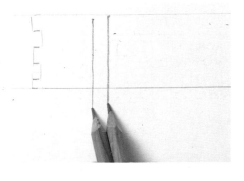

1 The Half-uncial N is very different from the modern letter. Start with a vertical line that descends below the writing line.

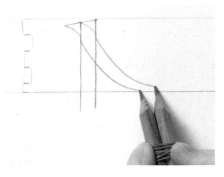

2 Add decoration to the top of the letter and make a slightly curved diagonal down to the writing line.

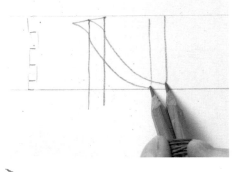

3 Draw a straight vertical to meet the end points of the diagonal line.

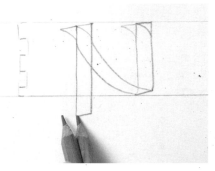

4 Add some decoration to the top of the second vertical and finish by closing up the bottoms of both vertical strokes.

Writing the letter Y

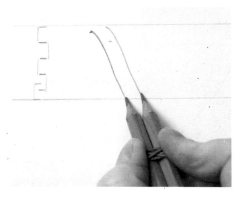

1 The key to writing letters with diagonal strokes is to balance the various parts that make it up. Start the Y with a straight diagonal between the two writing lines.

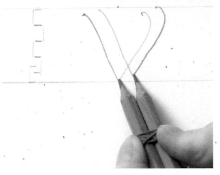

2 Start the second stroke with a quick curve but then bring it down to meet the end points of the existing stroke, ensuring the two sides balance.

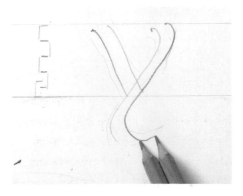

3 Continue the stroke below the line but quickly turn it into a smooth curve that heads back up toward the writing line.

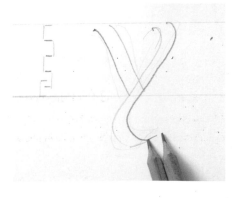

4 Finish by enclosing the bottom of the letter.

29

WRITING IN INK

To give the right weight to the pen-made strokes Half-uncial letters need to be written at a flat angle. They should be rounded in appearance, even when they include straight elements, as with the letter N, where the first downward stroke goes below the writing line. If you find the spacing between words is too long, or your writing has finished too short at the end of a line, then it is possible to add length to some of the finished strokes, as in the letter E. This could be a Celtic knot, scroll, or triskele design added to the tip to fill the space.

Writing the letter L

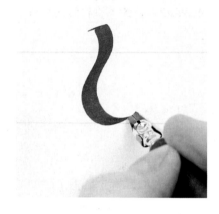

1 Begin the ascender above the top line and write the letter in one stroke, giving it a strong, fluid, curved appearance.

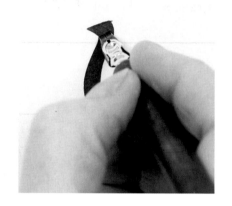

2 Finish the letter by adding a small decorative flourish to the top of the ascender.

Writing the letter X

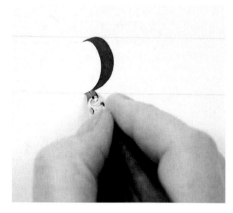

1 The letter X is composed of a series of rounded elements, the first of which is a tall anticlockwise curve between the writing lines of the stave.

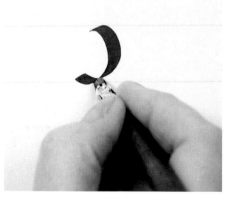

2 Add a return to the bottom of the curve, meeting the first line on the writing line.

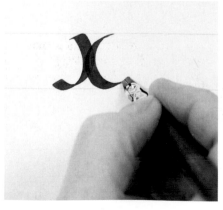

3 The third stroke is a mirror image of the first. Make sure the widest part of the curve covers the same part of the first stroke.

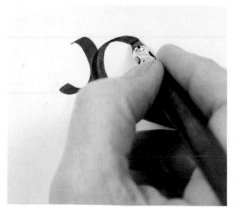

4 Finish by completing the curve at the top of the right-hand element of the letter.

Writing the letter B

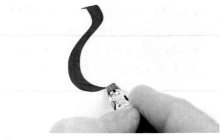

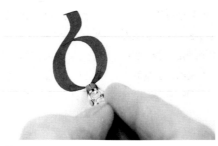

1 The main structure of the letter B replicates the L: give the form a smooth, flowing line.

2 Create the round bowl of the letter using all the space between the lines.

3 Emphasize the fish tail by adding a decorative stroke to the top of the vertical.

Writing the letter F

1 Start with the vertical, dropping it below the writing line as with the letter N.

2 Make the loop of the F starting with the thinnest part of the nib.

3 Finish with a straight horizontal stroke along the writing line.

Common Mistakes

The different elements of the M are too widely spaced

The horizontal stroke is too thin

The correct nib angle makes the top of the letter a suitable width

Keep the gaps in the letter even

The curved elements of the letter are too upright

Ensure the descender only drops 1½ pen widths below the writing line

Curves give the Half-uncial letters their flowing form

The descender is too long

Square Capitals

Celtic manuscripts used drawn letters as well as the Uncial and Half-uncial scripts. First outlined then filled in with ink, the letters were placed very close to each other. They were often decorated with bright colored panels as well as Celtic knots.

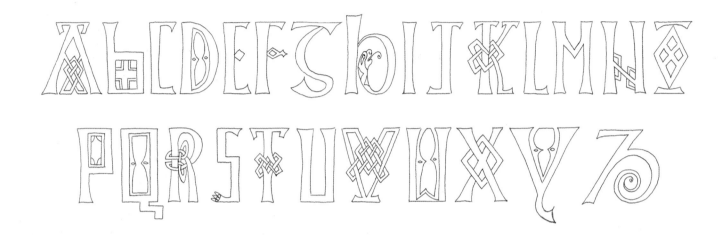

DRAWING SQUARE CAPITALS

Drawn between two pencil lines roughly 1½in apart, the letters are first worked lightly with a soft pencil, then drawn over with a fine-line black pen. Celtic knotwork panels make up some of the letters—the R is a good example showing the interlacing knotwork in the center bar of the letter. When used in manuscript the letters of this alphabet are usually surrounded by a band of straight colored lines at the top and bottom of the drawn line of text, and the height of each letter is usually written inside these painted lines.

Writing the letter D

1 Draw the outer lines of the vertical element first, giving them both slight inward curves.

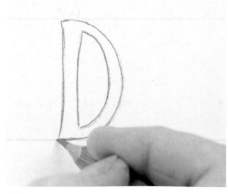

2 Draw the curves of the right-hand part of the letter, giving the letter an even thickness.

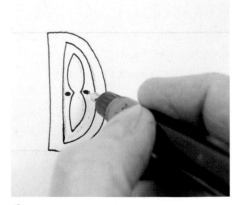

3 Draw the decoration inside the letter, adding dots to finish, then go over the whole letter with a fine-line black pen.

Writing the letter R

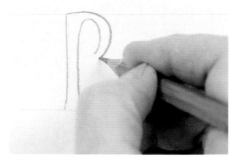

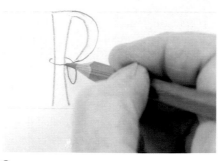

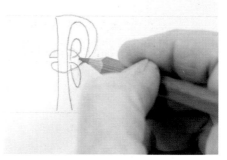

1 Start the letter like the D with concave vertical strokes, then add a smooth bowl curving towards the center of the vertical.

2 Bring the bowl to a point to the right of the vertical and start designing the knotwork by drawing the shape with a single line.

3 Bring the knotwork twice around the vertical, remembering to make the design move over and under itself in turn.

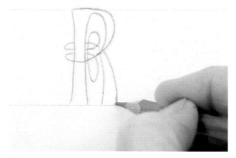

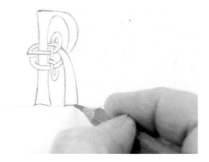

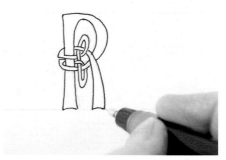

4 Add in the foot of the letter, widening it to match the bottom of the vertical but not going out wider than the bowl.

5 Go over the knotwork to make it up from two lines of pencil work.

6 Cover all the pencil with ink from a fine-line black pen.

Common Mistakes

Do not draw the letters too wide—they should always be rectangular in shape, narrow, and drawn close together on the writing line.

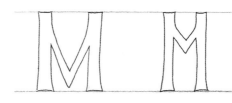

Do not make the central element too long. Make the strokes shorter and less pronounced.

Do not draw the descender stroke too far below the writing line and check where the elements of the letter join each other.

Cursive Capitals

This alphabet is based on letters found in the Lindisfarne Gospels. Also drawn and filled in with ink, some of the letters and spacing were painted in color. Both color and pattern played important roles with Celtic knot designs filling any open spaces.

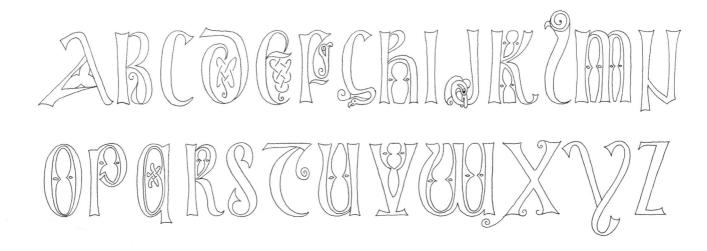

DRAWING CURSIVE CAPITALS

Cursive capitals are more rounded than the square capitals and some letters use decorations like zoomorphic animal heads to finish off the end of a letter. Other differences include some letters, such as the L, rising slightly above the top line while parts of the letters X and Y fall below the writing line.

Writing the letter S

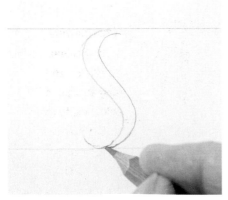

1 Begin with a smooth curve from the top to the writing line. Add the second side of the letter, smoothly following the rhythm of the first line but narrowing at top and bottom.

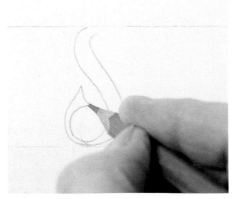

2 Add the tail to the base, opening it out and enclosing with a short curved line.

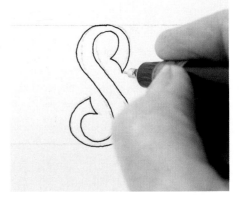

3 Repeat at the top of the letter, making the curves slightly smaller to give the letter balance. Cover the pencil with black ink and erase any remaining pencil marks.

Writing the letter M

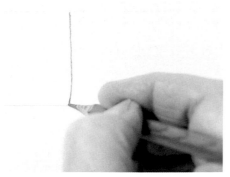

1 Using a soft pencil, draw a very gently curved vertical line from the top line down to the writing line.

2 Draw in the other side of the vertical, starting just below the top line to allow for the curve to follow.

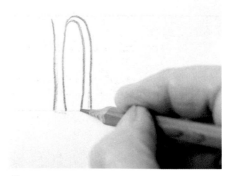

3 The left-hand curve of the letter is narrower than might be expected. Widen the foot at the bottom.

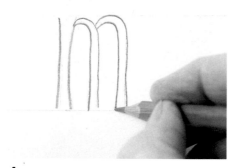

4 The right-hand curve is slightly wider to ensure the three feet are evenly spaced.

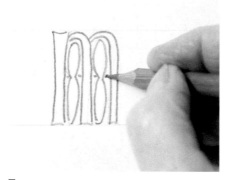

5 Enclose the feet and top of the vertical then add decoration inside the letter.

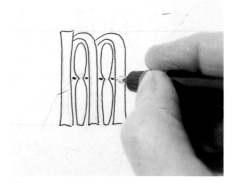

6 Cover the whole letter in black ink from a fine-line pen.

Common Mistakes

Try not to make the curved letters too round in appearance; the letter O especially should be oval in shape. Always draw the letters between the top and bottom lines.

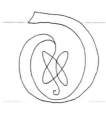

Draw the letters with even spaces between each letter and with extra space between each word.

Avoid drawing ascenders and descenders too long above and below the lines. Draw them no more than ½in below or above the line.

Runic Characters

The runic letters originate from Scandinavia and are much older than the Celtic alphabets. The characters are different to other alphabets in as much as they are symbols that do not correspond to specific letters of the modern alphabet. Originally carved on bone, wood, and stone, they are often seen on standing stones or archaeological finds such as carved hair combs. Runes were used for divination, and an object marked with one of the symbols was sometimes carried by the owner as a talisman for good luck or a safe journey.

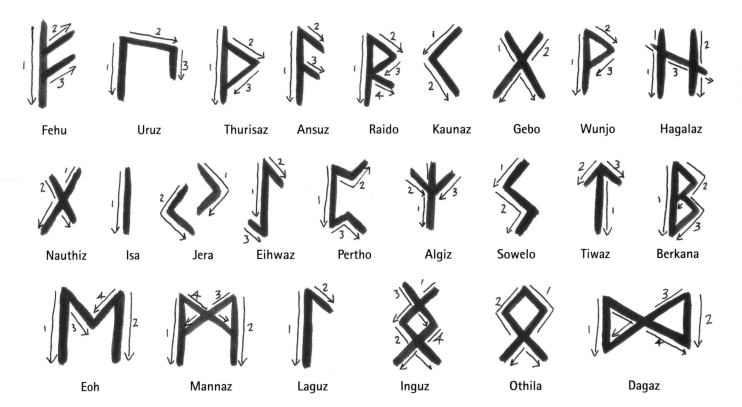

Fehu	Uruz	Thurisaz	Ansuz	Raido	Kaunaz	Gebo	Wunjo	Hagalaz

Nauthiz	Isa	Jera	Eihwaz	Pertho	Algiz	Sowelo	Tiwaz	Berkana

Eoh	Mannaz	Laguz	Inguz	Othila	Dagaz

WRITING RUNIC CHARACTERS

As all of the runic characters are made up of a series of free-flowing lines they do not suit being written with a steel-nibbed calligraphy pen which will not be able to replicate the even width of the elements. Instead it is best to write the characters using a soft, pointed paintbrush – ideally made of sable in size 1 or 2.

Start at the top of the stroke and write each character freehand. You do not draw lines before painting these symbols but it may help you to use writing lines when practicing them on paper. A felt tip pen is also useful for practice in drawing the lines of the runes, as the felt tip pen flows easily over the surface.

Writing the character Raido

1 Start with a simple vertical line between the writing lines.

2 Draw a triangular shape, rejoining the center line halfway along its length.

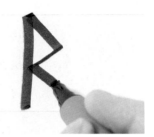

3 The final line should be written at the same angle as the top diagonal but it should stop well short of the bottom writing line.

Writing the character Eihwaz

1 Many runic characters are based around a straight vertical line. Start the Eihwaz with one.

2 The simple diagonals should be very short and run parallel to each other.

Writing the character Inguz

1 Some runic characters do look complicated but are generally very simple to write. Start the Inguz with a pair of diagonals at right angles to each other.

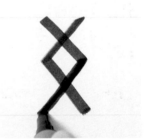

2 Repeat the diagonals in the opposite direction to create the finished character. Ensure that the two sides balance each other.

Writing the character Dagaz

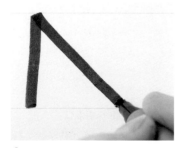

1 The size of the characters on the page can vary in the Runic alphabet. Start the Dagaz with a vertical and a wide diagonal from the top of the line.

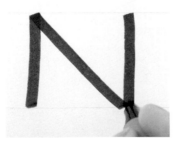

2 Draw a second vertical line to create a form like a very wide capital letter N.

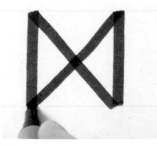

3 Finish the character by adding a second diagonal that mirrors the first.

Common Mistakes

Try to keep the paint or ink flowing freely and write each rune symbol with confidence. It does not matter if they are not of equal size—some of the symbols are smaller and others larger. Try to keep the brushstrokes all the same thickness—it will help make the runes look even, whatever their size on the page.

PROJECTS

Now that you've mastered the basic Celtic alphabets, put your hard work into practice in a range of beautiful projects that will show off your skills as well as enhancing your home and making beautiful gifts for your family and friends.

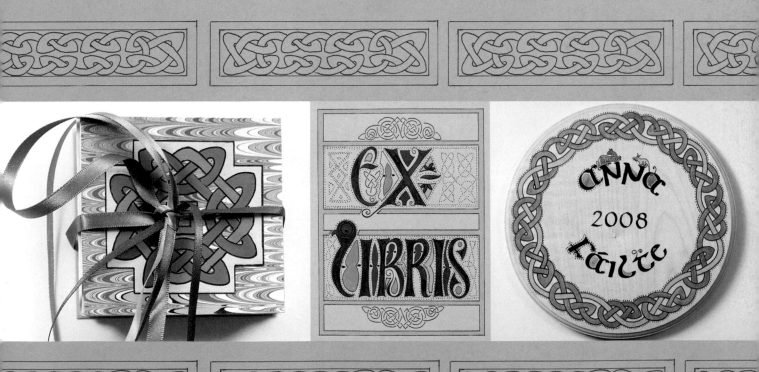

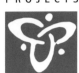

Wishing Stone

You can turn a stone found on any beach into a wishing stone, by holding it in your hand and feeling this ancient stone as you make a wish. Write in a freehand Uncial script with a steel pen using gouache color to give an authentic look, then varnish the stone with a spirit varnish to seal the design.

Materials

Flat beach stone
Gouache color—red,
 blue, cream, purple,
 green, and white
Palette
Gum arabic
Size C2 nib
Reservoir
Pen holder
Water jar
HB pencil
Size 5 and 1 brushes
Satin wood, spirit-based
 varnish
Flat varnishing brush

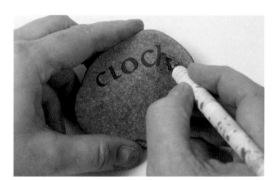

1 Wash the stone, allowing it to dry completely. Mix the purple gouache in a palette with a drop of gum arabic and water to the consistency of single cream with the size 5 brush. Place the size C2 nib into the holder and push the reservoir into the nib. Now brush the mixed gouache onto the back of the nib.

2 Using the pen write the words *cloch mianach*, meaning "wishing stone," freestyle—without pencil lines—in Uncial script. You could practice the words on paper first to become confident with the writing.

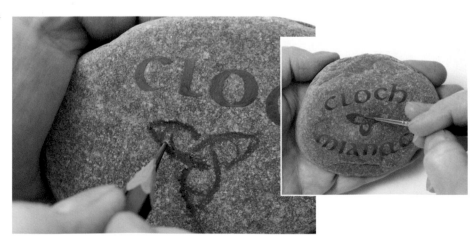

3 When the lettering is dry, lightly pencil the Celtic knot design (page 117) onto the center of the stone. Now use the size 1 brush loaded with the mixed gouache and go over the pencil lines until none show, and paint in the Celtic knot.

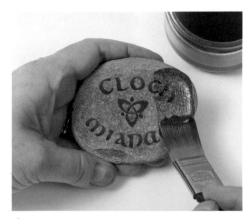

4 When the gouache is completely dry, apply the varnish sparingly over the lettering with the flat brush. Allow to dry overnight before handling the stone.

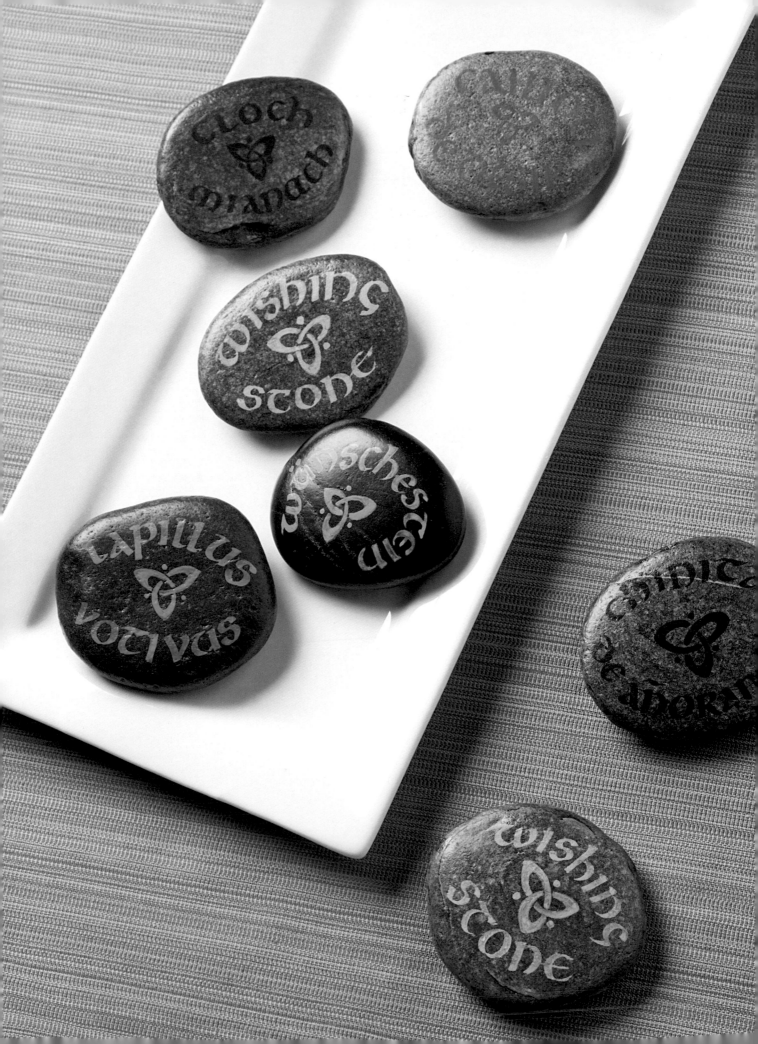

Name Plaque on Wood

This name plaque makes an unusual gift for a child or adult to adorn a bedroom door or wall. It is written on wood, a material sacred to the Celts, in the Uncial script with the use of interlacing Celtic designs above and below the name.

1 Varnish the wooden plaque using a flat varnish brush, stroking the varnish on as evenly as possible. The varnish will lift the grain so allow it to dry for 24 hours then work the fine sandpaper in a slow, even motion along the grain of the wood, taking off the excess dust with a soft cloth.

2 Copy the plaque's boundaries onto some tracing paper by drawing round it with a 2B pencil.

Materials

Oval wood plaque

Satin wood, spirit-based
 varnish

Flat varnish brush

Fine sandpaper

Soft cloth

Tracing paper

H and 2B pencils

Ruler

Eraser

Size C1 nib

Reservoir

Pen holder

Fine-line black pen

Masking tape

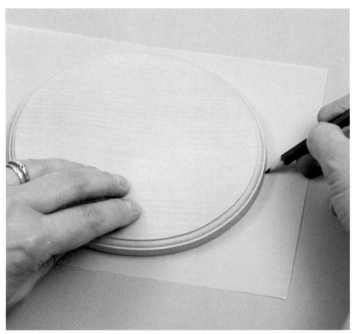

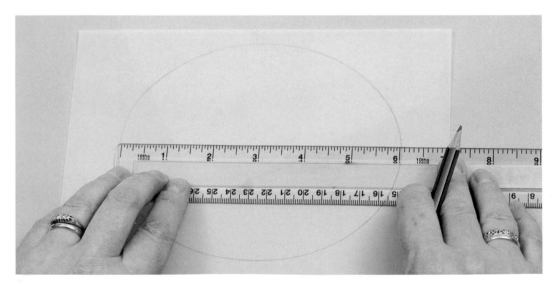

3 Measure the width of the plaque to discover the length of available writing space and draw a stave onto a piece of practice paper.

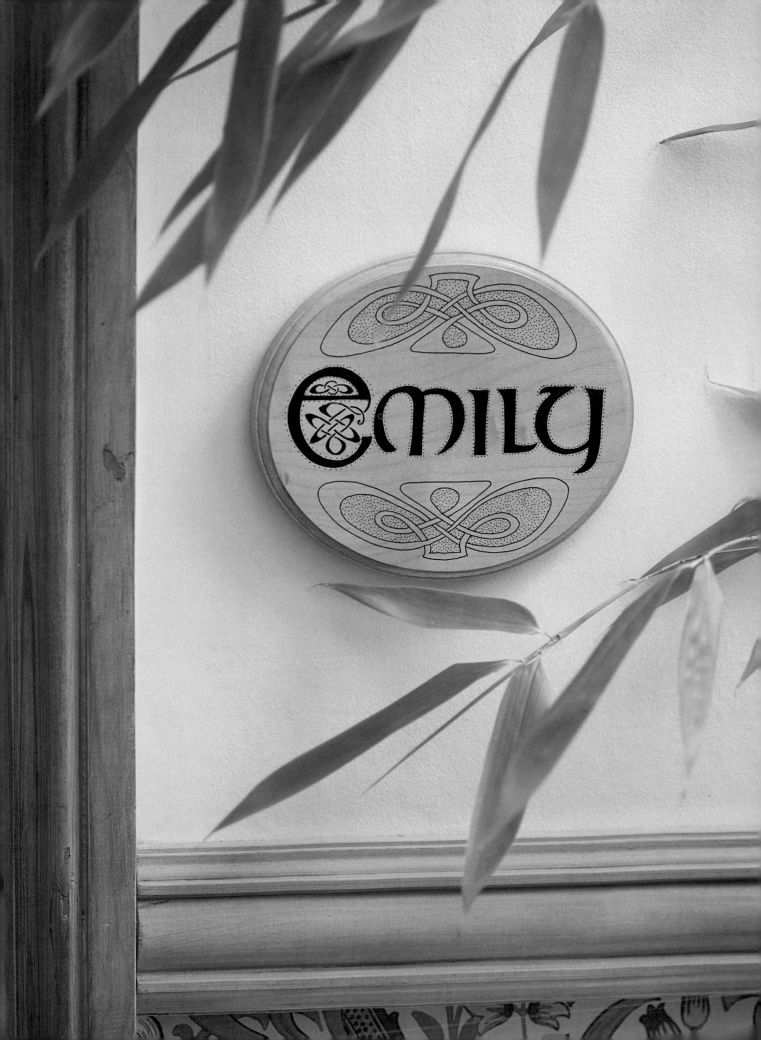

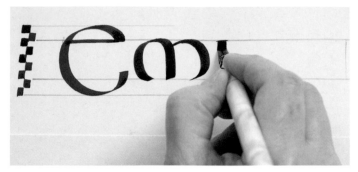

4 Using a size C1 nib draw up a stave of 4½ pen widths of the length measured in the previous step on a piece of plain paper, adding two pen widths above and below for the initial cap and marking the available length. Using the same nib, start practicing writing your name. If it is too long or short try again using a smaller or bigger nib, always discovering the height of the lettering by creating a stave using 4½ pen widths.

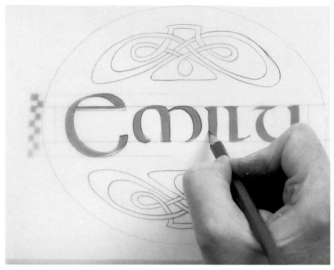

5 Trace the knot designs top and bottom from the template (page 122) onto the top and bottom of the trace making sure they are centered. Now trace over the name with a soft pencil.

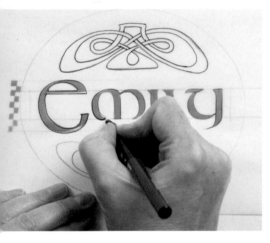

6 Go over the pencil lines with a fine pen so that you don't lose the definition of the lines when you carbonize the back of the paper.

7 Use the 2B pencil to carbonize the back of the tracing paper then place the trace onto the plaque and stick down on all four sides with masking tape. Go over all the black lines with the hard pencil to transfer the design from the underside tracing to the wooden plaque. Lift one corner of the tracing paper to make sure the design is showing.

8 Take the fine-line black pen and draw over all the pencil lines on the surface of the plaque. Move the plaque so that your hand stays in roughly the same position as you work.

9 Fill in the black areas of the letters and add the dots and decorations. Take care not to smudge the ink: only work in one direction so that your hand is never over the lettering. Leave to dry completely for a few hours.

10 Now seal the design by using a wide brush to cover the surface with varnish. Allow to dry for a day before handling.

Gaelic House-Blessing Card

It was traditional in the Celtic lands to give a blessing for a new home. This Gaelic blessing would be an ideal greetings card for a friend moving into a new house. It is written in the Irish Half-uncial script, using Celtic interlacing corner designs, and is finished with random color panels in the text.

1 Using the size C3 nib for the initial cap and the size C4 for the rest of the lettering, draw 4½ pen-width staves onto a piece of cartridge paper and practice the Half-uncial script.

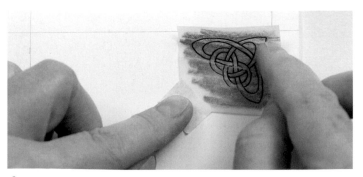

2 Fold a sheet of A4 paper in half to make an A5 card. Draw four lines ½in in from the edge around the card with a soft pencil then find the center point and draw a line down the card.

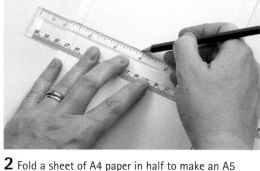

3 Trace the knot design from the template (page 117) in pencil then go over it in pen so that it retains definition when carbonized.

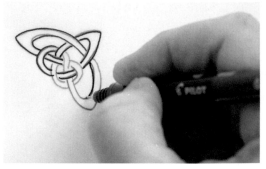

4 Carbonize the back, then cut out the motif and place it in the corner of the card sticking it down with masking tape.

Materials

Size C3 and C4 nibs	Ruler
Pen holder	Size 5 and 1 brushes
2 reservoirs	Gouache color – green,
Black calligraphy ink	gold, red, blue, and yellow
White cartridge paper	Gum arabic
Tracing paper	Palette
H and 2B pencils	Water jar
fine-line black pen	Eraser
A4 sheet of card	A5 size envelope

Bail o Dhia ar an dtig seo
o shuiomh go fanacht
o bhiom go falla
o chrioch go crioch

God bless this house
from site to stay,
from beam to wall,
from end to end.

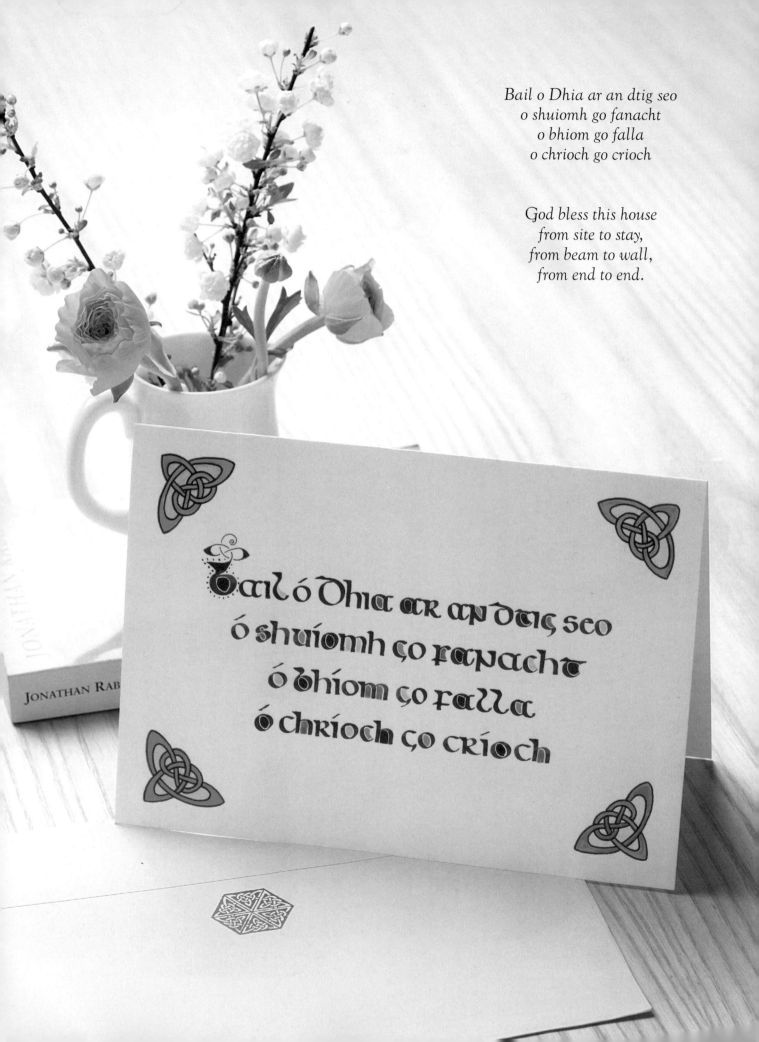

5 Use the hard pencil to transfer the design through to the card. Move the motif to all the corners of the card and repeat.

6 Measure 2in from the top of the card and draw a line across the card with the soft pencil to make the top of the upper stave. Now draw the other lines to make staves for the four lines of text. Allow ½in between the lines, making sure you allow for the larger initial letter at the beginning of the first line.

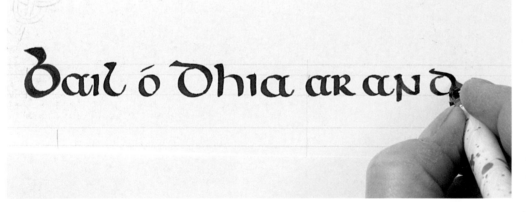

7 Measure the length of the practice lines and mark them onto the final sheet, centered around the vertical line. Write the Celtic blessing in black ink, starting with the initial letter B in the size C3 nib followed by the rest of the text in a size C4 nib. Add decorative space fillers at the end of each line if necessary.

8 Paint the knot decorations with a fine, size 5 brush using green gouache mixed with a drop of gum arabic, then fill in the rest of the design with gold.

9 When dry, use the fine-line pen to outline the corner designs in an over and under pattern.

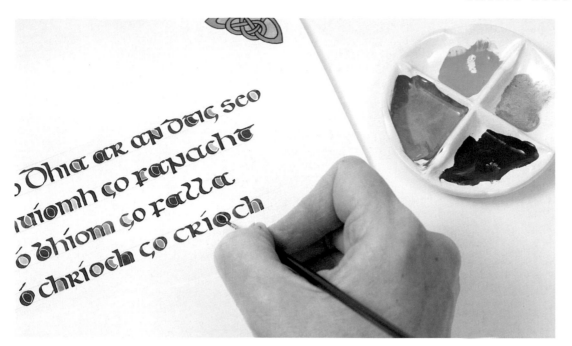

10 Mix up a little of the other colored gouache and using the size 1 brush, decorate some of the letters at random.

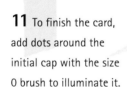

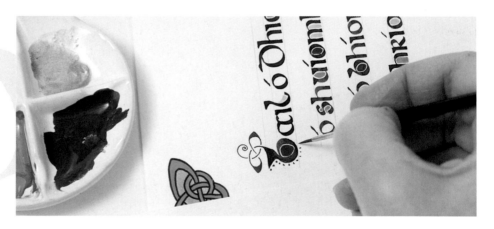

11 To finish the card, add dots around the initial cap with the size 0 brush to illuminate it.

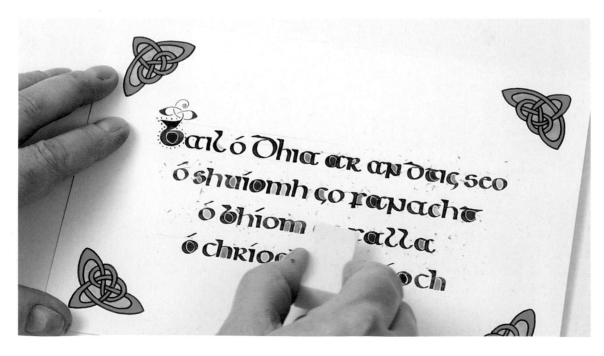

12 Once the paint is completely dry carefully erase the pencil lines.

Wooden Picture Frame

Here, a simple wooden frame is painted in a pastel color using water-based craft paint. A black Celtic knot border has been added around all four sides, and each corner has a simple Celtic square motif painted with lavender pearlized paint.

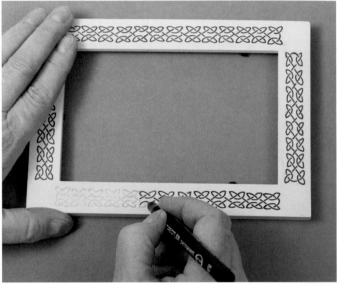

1 Cover the plain wooden frame with the pastel acrylic paint using a flat brush to stroke on the paint evenly, allowing it to dry completely. Trace the Celtic knot border design from the template (page 117). Use the soft pencil to carbonize the back of the design before tracing the Celtic design onto each edge of the frame with a hard pencil.

2 Use the fine-line black pen to go over the pencil lines on each side of the frame.

Materials

Wooden picture frame
Acrylic pastel green paint
Flat soft brush
Tracing paper
Masking tape
H and 2B pencils
Fine-line black pen
Metallic acrylic paint
Size 0 brush

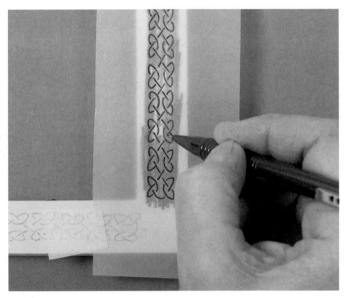

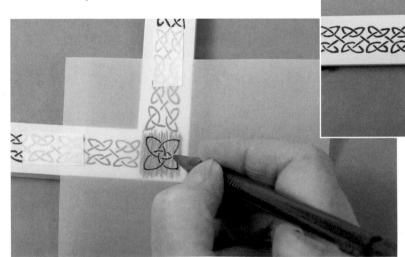

3 Trace the corner design (page 117) onto all 4 corners of the frame. Work in the same way as before, carbonizing the pattern before transferring the design onto the frame using the hard pencil and covering with the fine-line black pen.

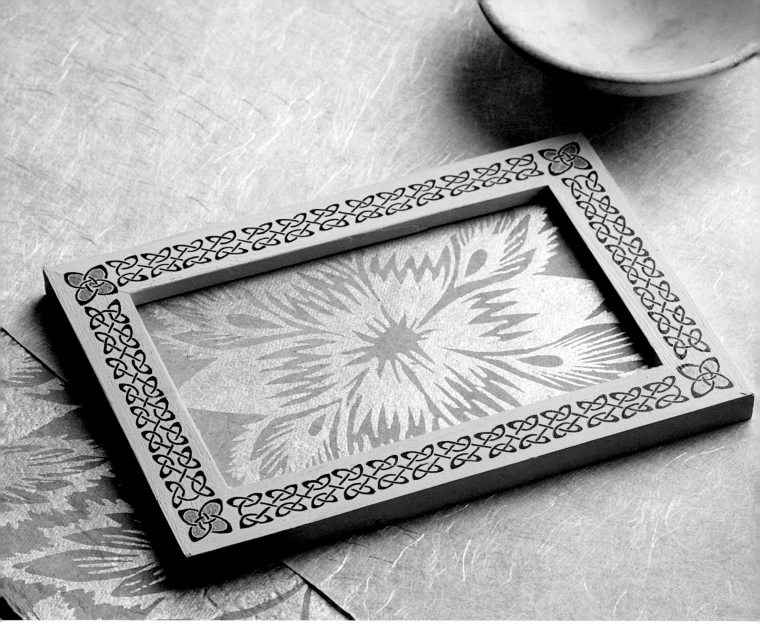

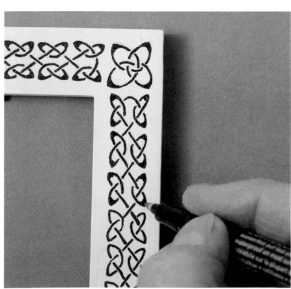

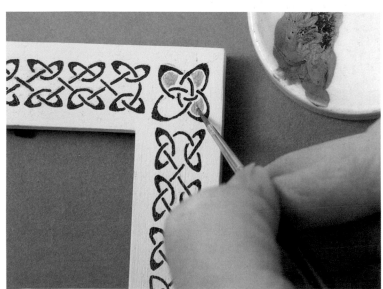

4 Emphasize the pointed corners of the knot design on both the corner motifs and border by thickening the insides of the turns with the black pen.

5 Highlight the corner designs by filling in the motifs with the metallic acrylic paint, using a size 0 brush.

Scottish Travel Blessing

The ancient people of Celtic lands often used travel blessings. This blessing comes from the Isle of Skye, on the west coast of Scotland, which still holds to age-old Celtic traditions. Written in Gaelic, this blessing wishes the safe return of a loved one traveling far away from home. The translation can be found overleaf.

Materials

A3 tracing paper
Stencil card (9½in square)
H and 2B pencils
Cutting board
Craft knife
Masking tape
A3 green Canson card
Gold pearlescent ink
Palette
Stippling brush
Water jar
A3 cartridge paper
Pen holder
Size C1 and C2 nibs
2 reservoirs
Black calligraphy ink
12in ruler
Zinc white gouache
Gum arabic
Size 3 brush for mixing
Windsor green gouache
Eraser

1 Trace the Celtic star motif from the template (page 123). Take the stencil card and find the center point by measuring the card both ways and draw two lines to make a cross in the center. Now carbonize the reverse of the tracing paper with the 2B pencil before placing it onto the middle of the stencil card. With an H pencil go over the design, transferring it to the card.

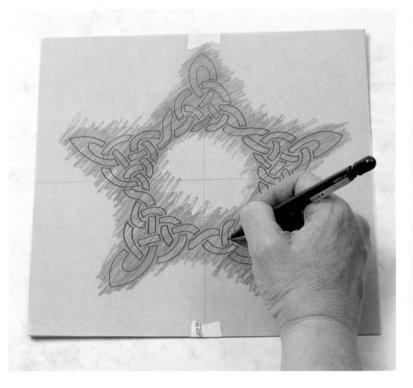

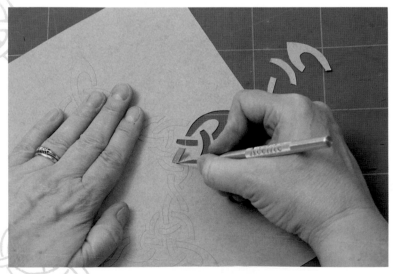

2 Place the stencil card on a cutting board and carefully cut out the design with a craft knife. Take care not to accidentally cut between the line design.

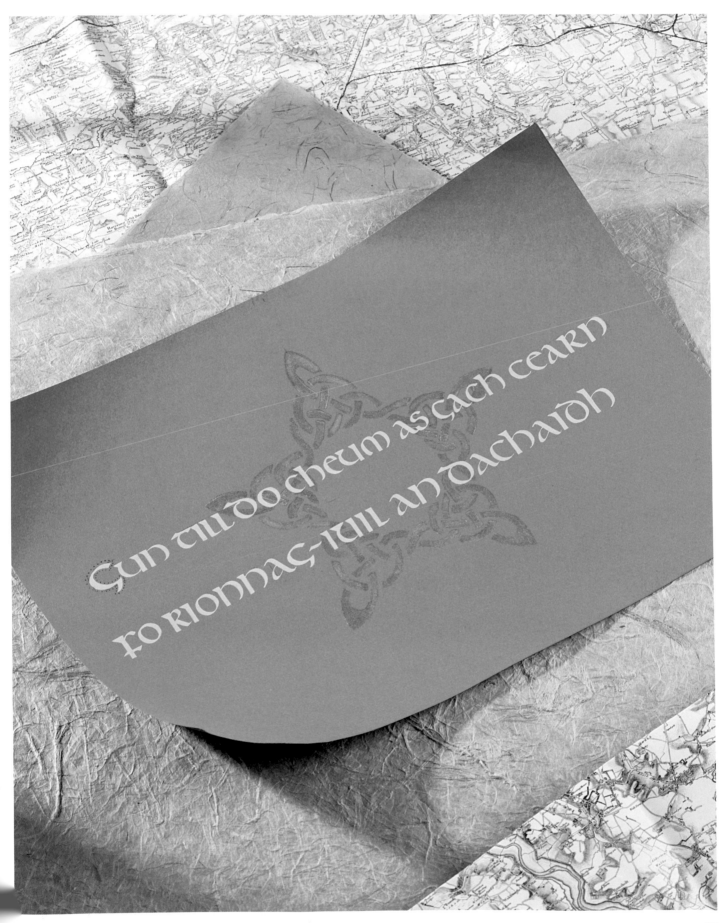

Gun till do cheum as gach cearn
fo rionnag-iuil an dachaidh

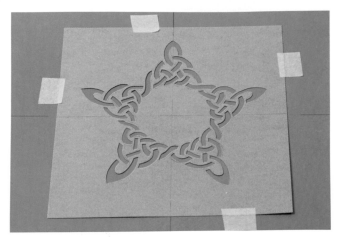

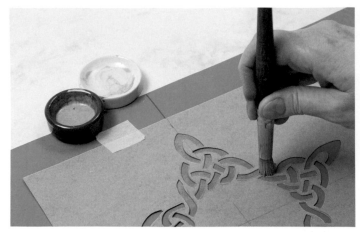

3 Measure the A3 green card to find the middle points of each side and mark lines 4in in from the edges. Place the stencil onto the green card so that the lines match up and and stick in place with masking tape.

4 Now mix some gold ink into a palette and dip in the stippling brush, taking off the excess ink on a spare piece of card, by pressing and using circular movements. Then stipple through the cut stencil to apply the gold color. Try not to put too much paint onto the stencil as it can seep under the cut stencil and spoil the design.

Tip

● When cutting the stencil take care to leave small joins of paper where one part of the design goes underneath another. If you cut too close you may not be able to make out which part of the design is uppermost.

● The stencil card can be tough to cut through. If the blade doesn't go all the way through turn the card over and press gently along the impression of the cut that will be showing through to make the final cut.

Ꝼ Ⲅun till do cheum as ɕach cearn

Ꝼ ꝼo rionnaɕ-iuil an dachai

5 Practice the writing on a piece of A3 cartridge paper. Draw a stave with the size C1 nib by drawing lines top and bottom to give the x height – this is for the letter G. Now do the same for the rest of the writing using a size C2 nib. Measure the lines of writing.

6 Transfer the writing lines to the green card. Start by measuring down from the top of the green card 4in. Draw a pencil line lightly with a soft pencil for the top line of the writing. Leave 1¼in between the writing lines. Measure the practice writing and draw a start point onto the green card.

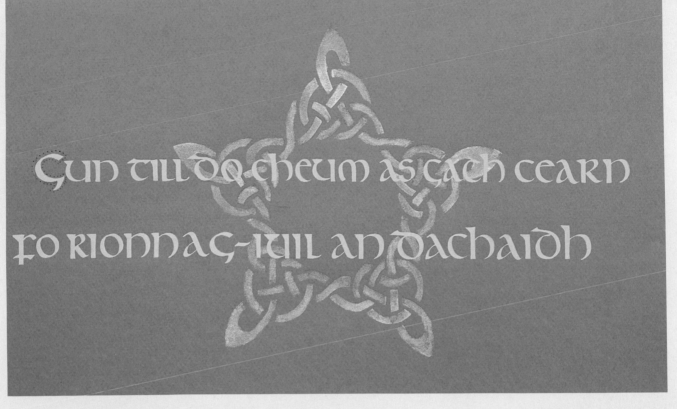

Gun till do cheum as gach cearn

Fo rionnag-iuil an dachaidh

May your steps return from all the corners of
the globe under the guidance of the star that
points to home.

7 Mix the white gouache with a drop of gum arabic and a little water, adding a little drop of green gouache to the palette and mixing well using the size 3 brush to make a very pale green that will be visible against the dark green. Write the card, starting with the size C1 nib for the letter G and continuing with the size C2 nib for the two lines of writing.

8 When the writing is completely dry, add black dots around the letter. Erase all the pencil lines when completely dry.

Illuminated Letter R

Manuscript illumination was regarded as one of the most beautiful and skilled

techniques of the scribe. Here, you can make your own illuminated letter to frame.

Draw an initial letter and adapt the Celtic knot pattern from the template on

page 119, adding an angel or animal design to complete the project.

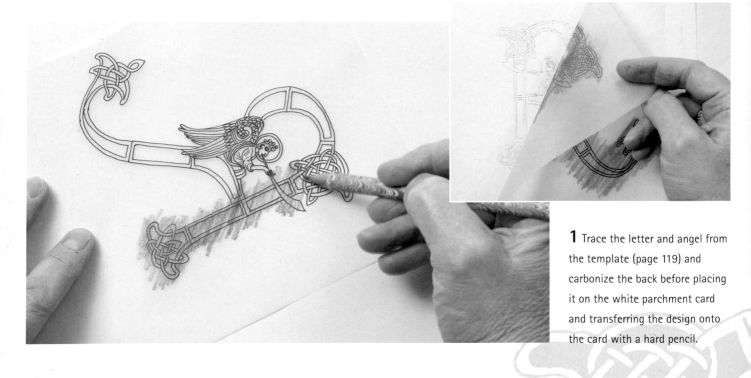

1 Trace the letter and angel from the template (page 119) and carbonize the back before placing it on the white parchment card and transferring the design onto the card with a hard pencil.

Materials

Tracing paper
H and 2B pencils
White parchment card
Fine-line black pen
Gouache color—yellow,
 purple, red, white,
 and gold
Gum arabic
Palette
Water jar
Size 0, 1, 2, and 4 brushes

2 Start by drawing over the pencil lines with the fine-line black pen, making it easier to paint the yellow inside the fine Celtic knotwork.

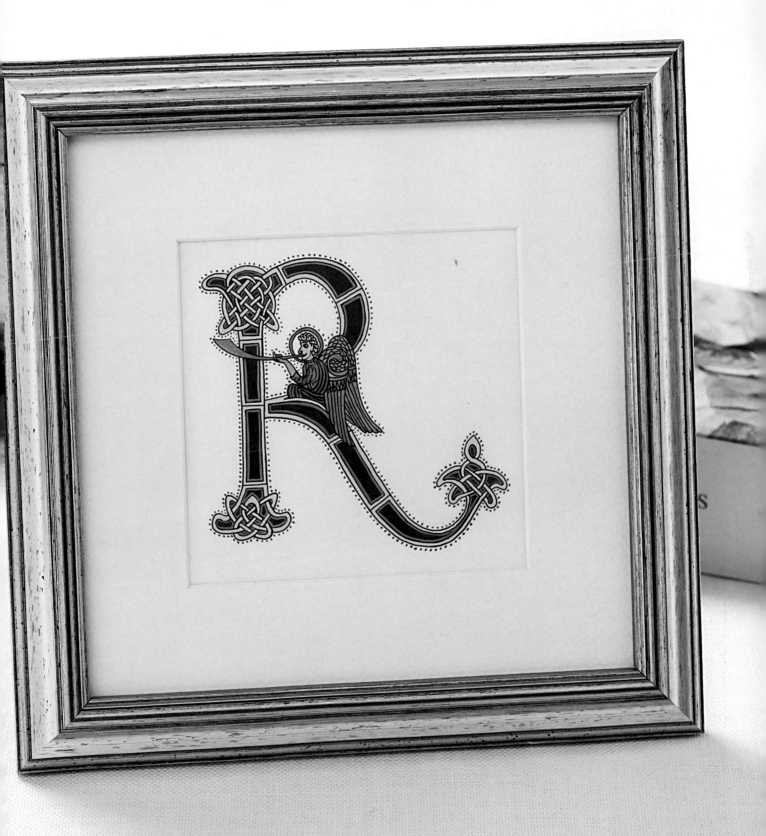

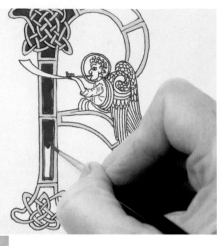

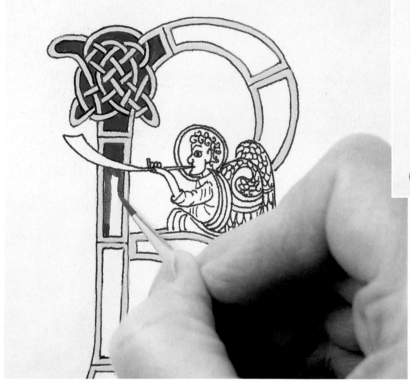

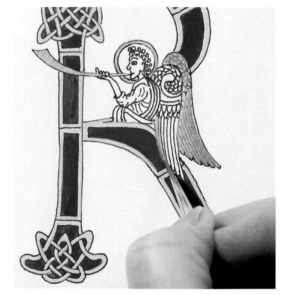

3 Mix some yellow gouache with a drop of gum arabic and a little water in a palette. Use the size 1 brush to start painting in the yellow edging. Next, mix some purple with a drop of white in the same way, using the size 3 brush in the larger areas. Paint an outline along the black edge first then fill in the rest of the area.

4 Now start painting the angel using the gold gouache: mix in the same way and paint in the wings, halo, and trumpet. Cover the whole wing including the black lines.

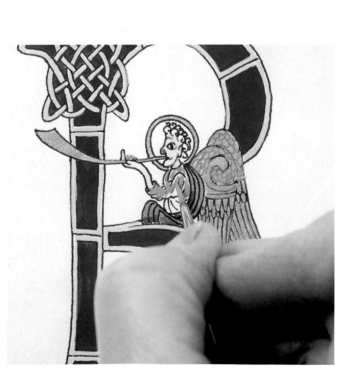

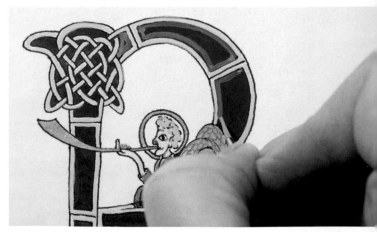

5 Paint in the rest of the angel using red, orange, and pink gouache, mixed from the colors on the palette.

6 Now mix some more white into the purple gouache to make a lilac color. Paint a fine-line with the size 1 brush, next to the black outline on the outside edge of the purple.

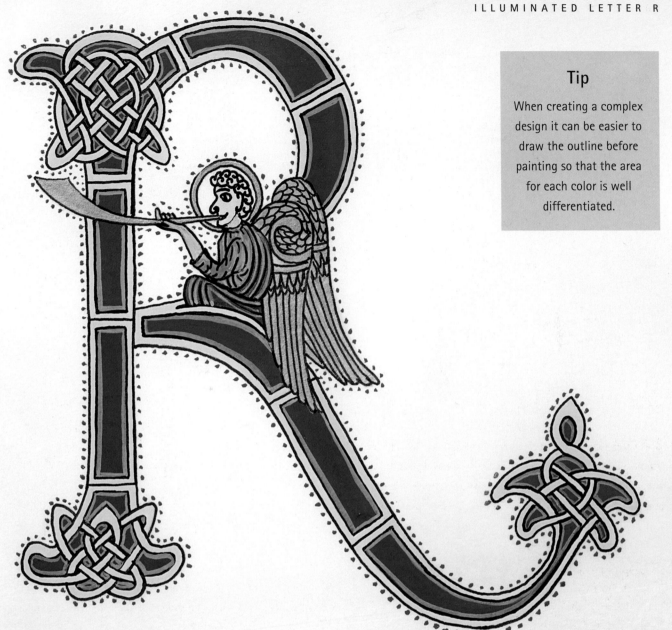

Tip

When creating a complex design it can be easier to draw the outline before painting so that the area for each color is well differentiated.

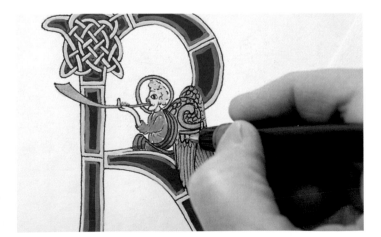

7 Go over the black outlines of the wings and any other part that has been accidentally covered with paint using the fine-line black pen.

8 Finally, mix red gouache, gum arabic, and water and use the size 0 brush to put dots all the way around the letter and angel.

Ex Libris Book Plate

This gospel-inspired book plate uses curved capital letters taken from the Lindisfarne

Gospels written on Holy Island, Northumberland. The space in the center of the design

is left blank so that the owner's name can be added.

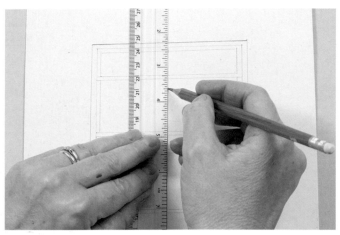

1 Draw up a grid on a practice sheet of card 4½in wide and 6in high, making spaces for two lines of letters 1½in high and the different knotwork decorations.

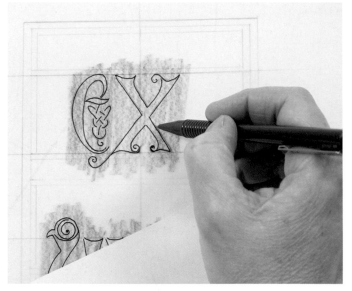

2 Trace the letters from the template alphabet and transfer them to the practice paper, placing the top line slightly to the left of center to allow for a piece of knotwork decoration.

Materials

Practice paper
12in ruler
H and 2B pencils
A4 tracing paper
Masking tape
Fine-line black pen
Size 000, 0 and 4
 brushes
Gouache color—
 crimson, scarlet, blue,
 green, yellow, and white
A4 lilac card
Black calligraphy ink
Gum arabic
Palette
Water jar
Silk marbled paper
PVA glue
Eraser

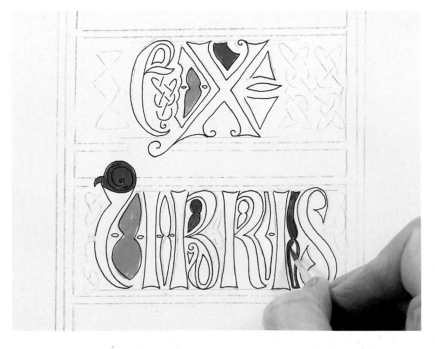

3 Trace in the knotwork panels then work up the colors, experimenting with different color combinations. Use gouache paints and a size 0 brush.

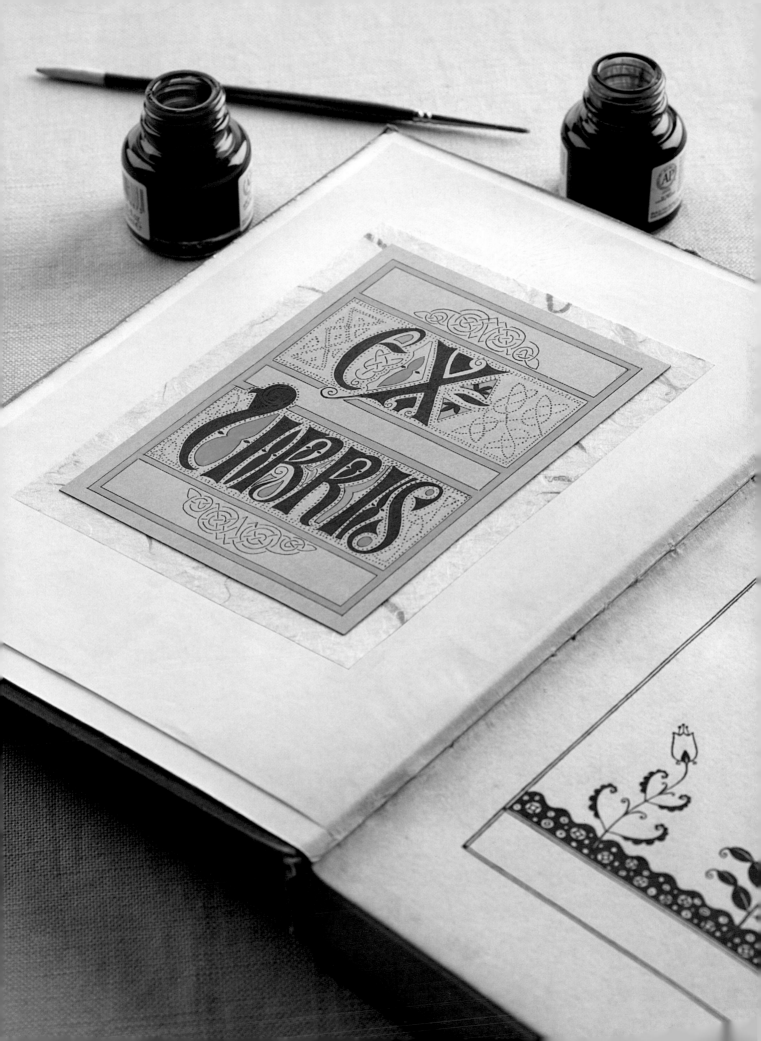

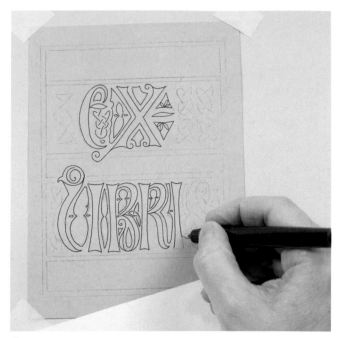

4 Take the final card and replicate the box then trace in the letters and knotwork again. Then cover the pencil lines with the fine-line black pen.

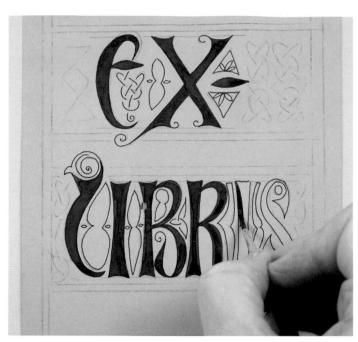

5 Fill in the letters with black calligraphy ink using a size 0 brush.

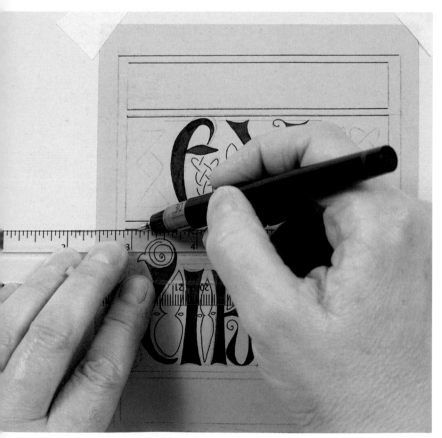

6 Cover the lines of the box and the letter decorations using a fine-line black pen.

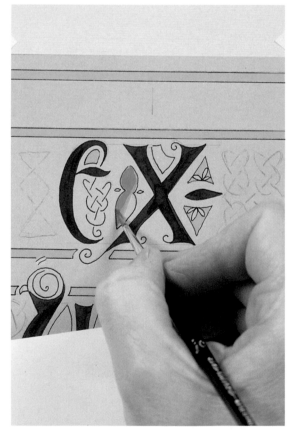

7 Paint in the color panels following the practice sheet you made earlier.

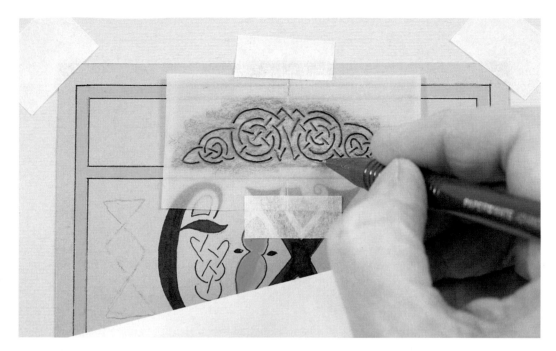

8 Trace the knotwork used at the top and bottom from the template (page 120) and transfer them onto the card, then go over the pencil lines using the fine-line black pen.

9 Highlight the rest of the decoration with dots, using red gouache and a size 000 brush.

10 Stick the card to a piece of silk marbled paper with PVA glue then rub out any remaining pencil lines with an eraser.

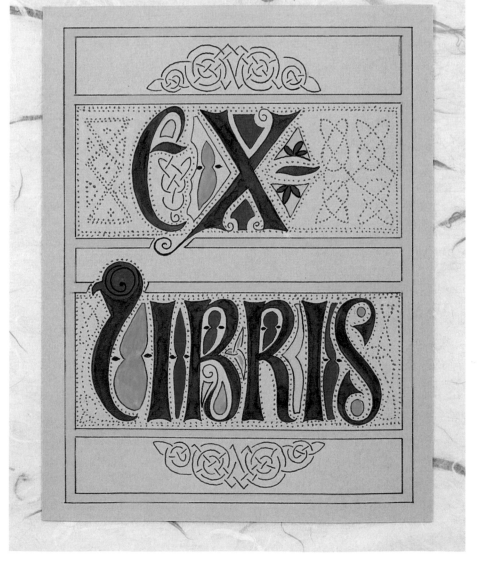

Uncial Place Card

This place card project is easy to achieve and is perfect for a special occasion, such as a dinner party or wedding. The Uncial script is complemented with an imaginative romantic heart motif and a simple Celtic border design.

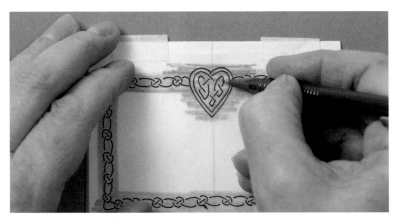

1 Measure across the front of the place card to find the center, draw a line down the center, leaving space for the main heart motif. Trace the heart and knotwork border design from the template (page 117) and carbonize the back before placing it over the center line and tracing through with a hard pencil.

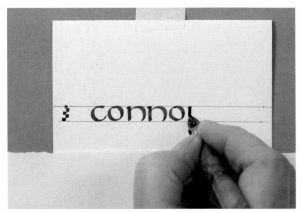

2 Draw a stave 4½ pen widths high on a spare card to find the height of the Uncial lettering and rule across in pencil before practicing writing the name.

Materials

12in ruler

White card cut to A5 size or bought place card

Tracing paper

H and 2B pencils

Masking tape

Pen holder

Size C4 nib and reservoir

Black calligraphy ink

Size 0 brush

Red gouache

Palette

Gum arabic

Water jar

fine-line black pen

Ink drawing pen

Eraser

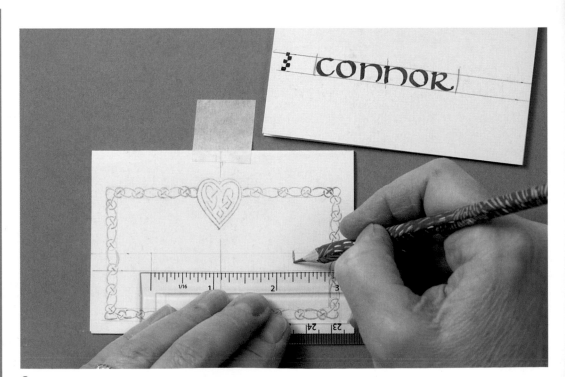

3 Now measure the length of the word and mark the start and finish on the place card, centering it on the pencil line drawn in Step 1.

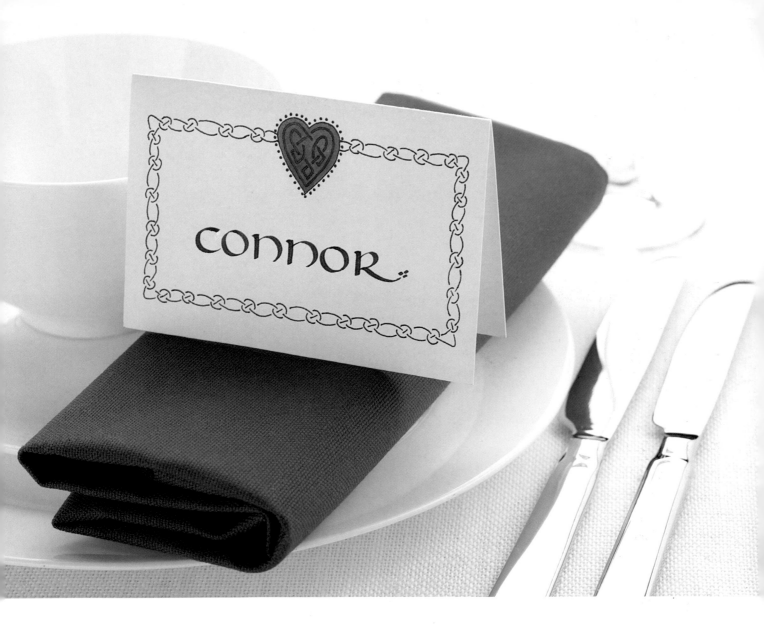

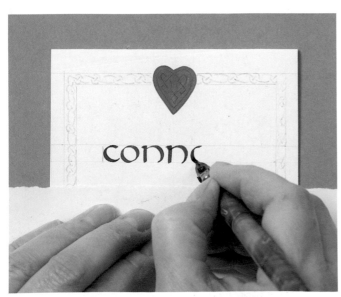

4 Paint in the heart with red gouache, after mixing a little in the palette with a drop of gum arabic and water. Use the size 0 sable brush and leave to dry. Write the name in black ink with the size C4 nib.

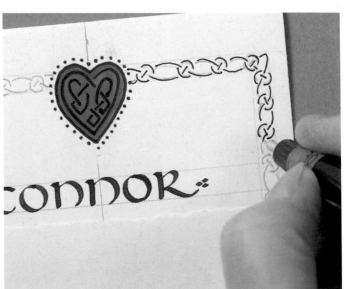

5 Go over the design inside the heart with a permanent fine-line black pen and then add dots around the heart. Finally use an ink drawing pen to go over the border. When dry erase the pencil lines.

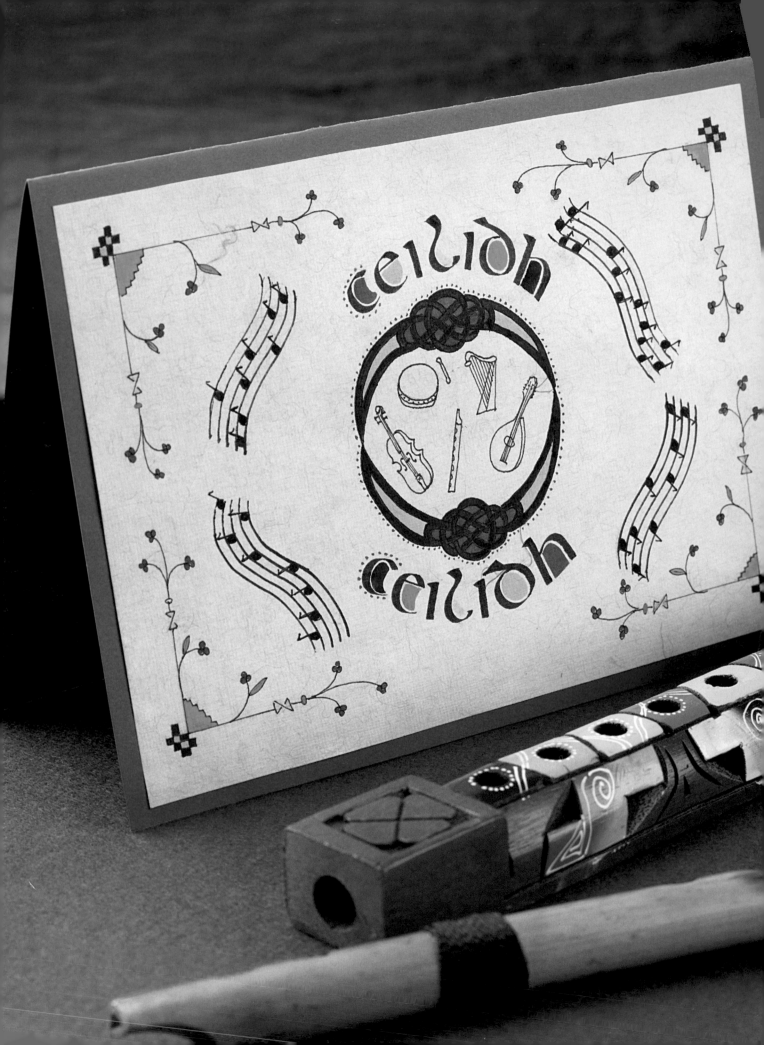

Ceilidh Invitation

For many centuries in Celtic lands, traditional music and dancing have been enjoyed and are still practiced today. This card design includes traditional instruments, and the Celtic corner border with flowers and motifs is inspired by the Book of Kells.

Materials

Practice paper
Compass
Pen holder
Light blue silk paper
Size C4 nib and reservoir
Black calligraphy ink
12in ruler
Tracing paper
H and 2B pencils
Masking tape
Fine-line black pen
Automatic 5-point pen
Size 000, 1 and 4
 brushes
Gouache color—scarlet,
 Prussian blue, emerald
 green, lemon yellow, and
 zinc white
Gum arabic
Palette
Water jar
Eraser
Blue A4 card

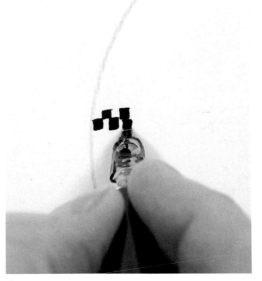

1 Draw a 2in diameter circle with a compass on a sheet of practice paper then draw a stave inside with a pen and size C4 nib. Recalibrate the compass and draw the bottom writing line from the end of the stave.

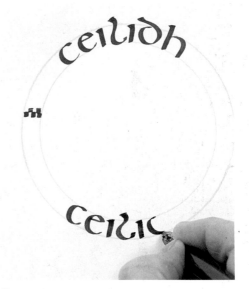

2 Practice writing the word "ceilidh" in Half-uncial letters, curving it in both directions.

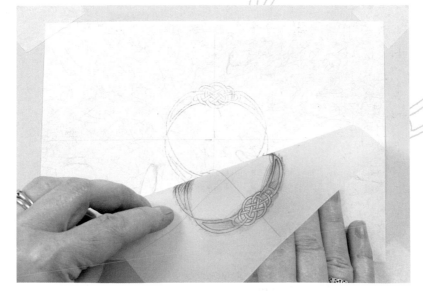

3 Find the center of the card by drawing lines from the middle of both sides then draw a cross on a piece of tracing paper and trace the central design. Carbonize the back and transfer it to the silk paper, centering it over the cross.

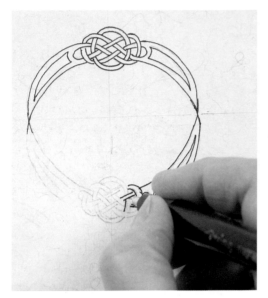

4 Cover the pencil design with fine-line black pen.

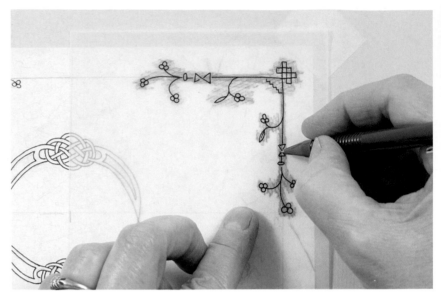

5 Draw a pencil rectangle around the edge, then place a tracing of the corner motif template (page 121) on each corner and transfer, covering with ink.

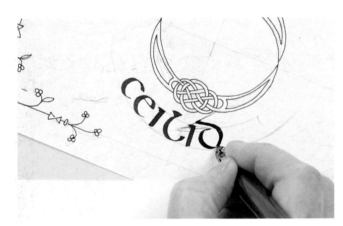

6 Pencil in the writing circles onto the paper with the compass and write in the letters with ink.

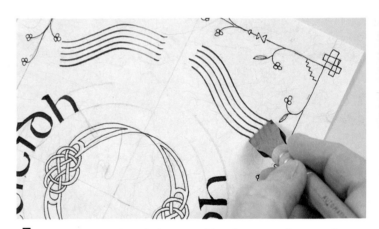

7 Draw in the curved musical staves with a five-pronged automatic pen.

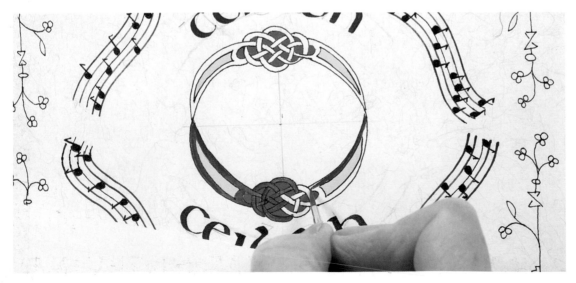

8 Draw musical notes onto the staves using the fine-line black pen then color in the decoration with gouache and a fine paintbrush.

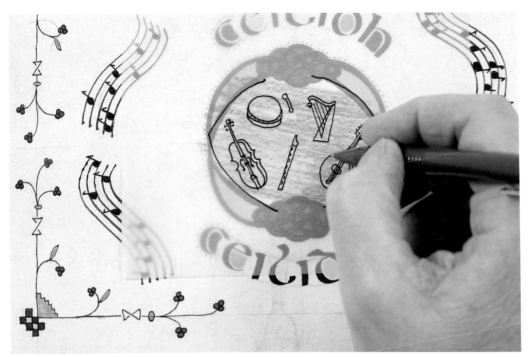

Tip

When writing in a circle with a pen and nib turn the paper as you move from letter to letter so that your pen is always upright.

9 Trace musical instruments (page 120) and transfer them onto the center of the invitation. Draw over with the black pen. Stick the paper onto a sheet of stiff card.

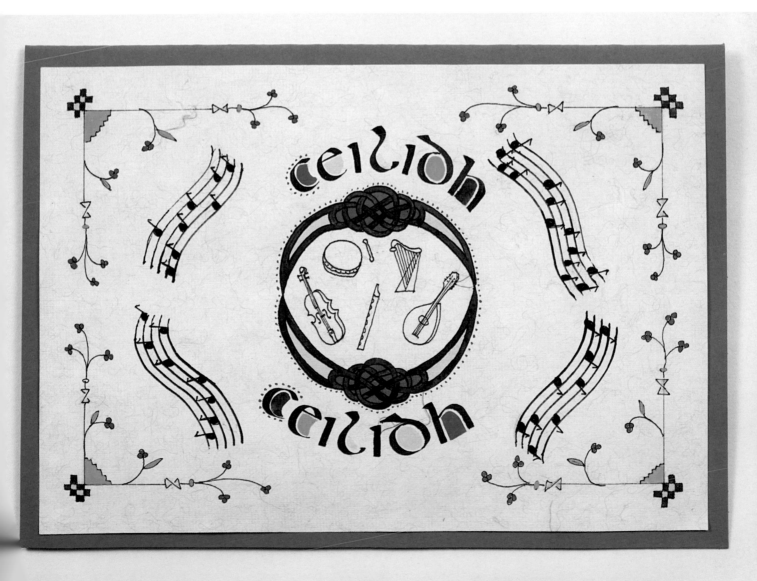

Slate Welcome Sign

This bright bold sign, reading "Failte," means "welcome" in Gaelic. Painted on slate, a

natural ancient surface, in angular square capitals in the style of the great manuscript

books of the eighth century, this sign could have come from early Celtic times.

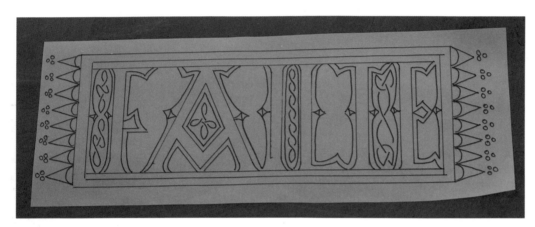

1 Use the image below as a template and enlarge it on a photocopier, then transfer the design to a sheet of tracing paper. Keep the lines of each letter as straight as possible. Draw the decoration around the wording (page 124).

Materials

A4 tracing paper
White chalk
Piece of slate
12in ruler
White chinagraph pencil
Masking tape
Ballpoint pen
Acrylic colors—red, blue,
 green, yellow, and white
Size 1 brush
Size 3 brush for mixing
Palette
Water jar
Fine-line black pen
Soft rag

2 Carbonize the back of the tracing paper with white chalk, making sure you have a lot of chalk on the tracing otherwise the design will not transfer successfully to the slate.

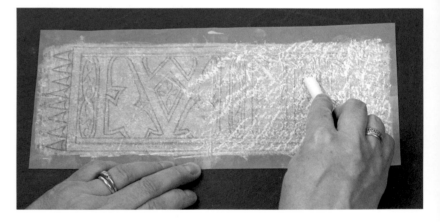

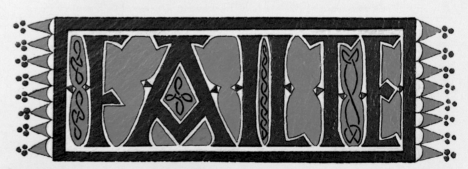

Create a color sketch of your design before starting to work on the slate to check that the colors you have chosen combine together well.

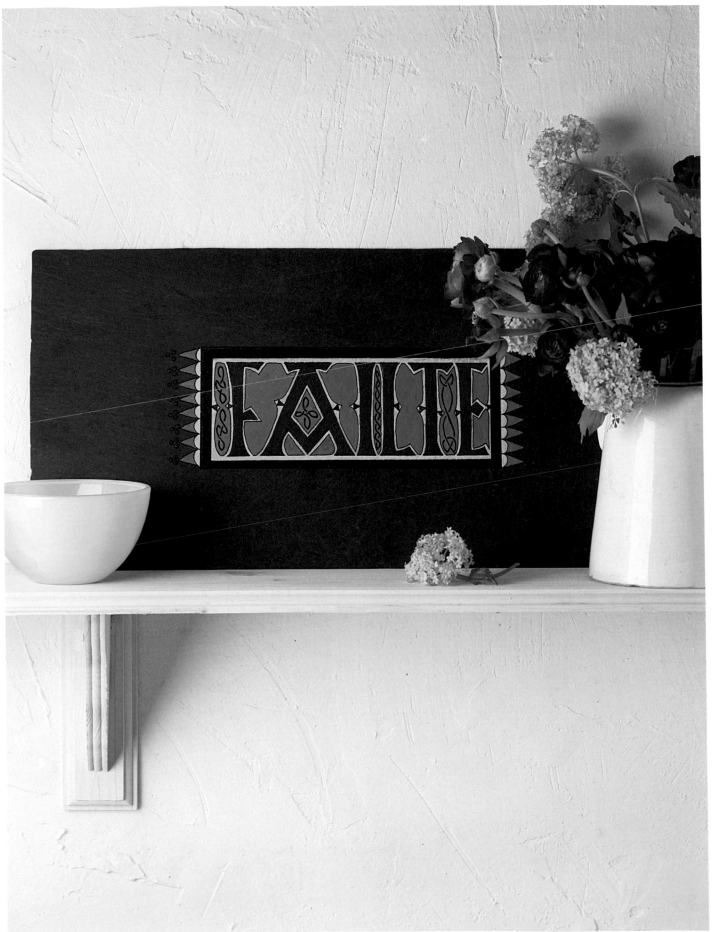

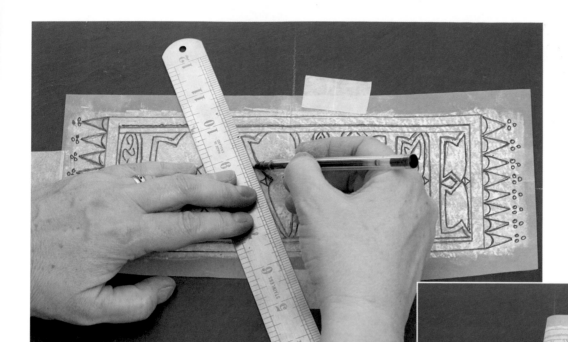

3 Take the slate and find the center point by measuring it across and down, marking at top and bottom with a white chinagraph pencil. Draw a line from top to bottom and side to side. Place the trace in the center of the slate, sticking it in place with masking tape. Now use the ballpoint pen to draw along your pencil lines with firm pressure to transfer the design onto the slate.

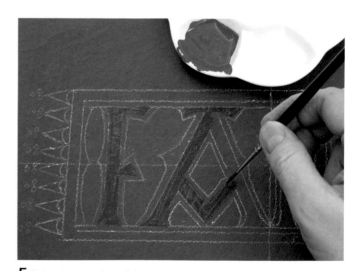

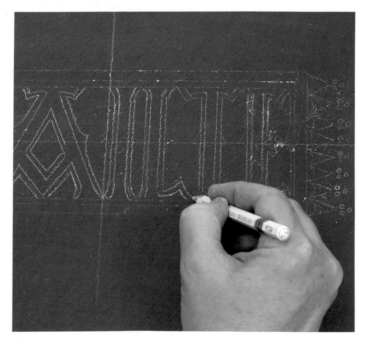

4 Before you start painting use the chinagraph pencil to emphasize the traced image.

5 Paint the lettering of the word "failte" using the size 1 brush and red acrylic paint. Mix a little paint into a palette with the size 3 brush and add enough water to make it a smooth consistency. Do not mix too much water and make the paint too runny.

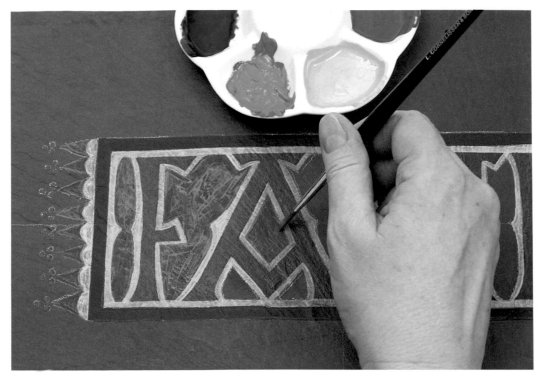

6 When the red paint is dry continue to paint with the yellow, blue, and green paints. Allow each to dry before applying the next color. You will need to paint all the colors several times to achieve a solid, consistent finish on the dark slate.

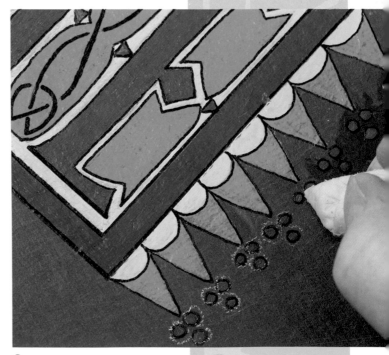

7 Now use the permanent marker pen to highlight the edges of each color and to add some Celtic knots to the design. Either draw your own designs freehand or trace one of the templates (pages 116–125) in the same way as before.

8 Finish the design by using a soft rag and some water to remove any white chinagraph or chalk lines still visible on the slate.

Anniversary Plaque

Here is a unique project to give as an Anniversary gift to remember a special day. Based

on the pages of illumination from the Book of Kells, it uses a border of interlacing

Celtic knots of bright colors to add a textured look to the project.

1 Take A3 tracing paper and draw a line across for the top of the frame. Trace the three border elements from the templates (page 124) onto a small sheet of tracing paper and place this underneath the A3 tracing paper and first trace a corner section. Then move the traced template so that a rectangular element is abutting the corner and trace this. Continue until the entire frame is on the large piece of tracing paper.

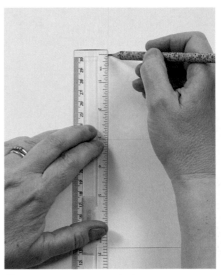

2 On a sheet of A3 card make a mark 3in up then a full line ¾in above. Measure across the page and mark the center point and draw a vertical line. Measure 4in above the top line and make another mark.

Materials

A3 and A4 tracing paper

18 or 24in ruler

Flexible curve

H and 2B pencils

Fine-line black pen

Cream A3 card

Practice paper

Pen holder

Size C1 nib and reservoir

Black calligraphy ink

Color pencils—cerise,
 purple, green and yellow

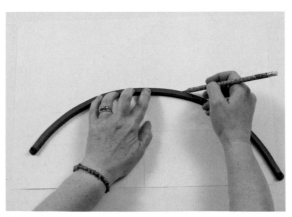

3 Take a flexible curve and bend it into an even curve. Place its center on the mark just made and draw a curve. Measure up ¾in and draw a second curve, slightly widening the arc of the flexible curve to maintain the ratio between the lines.

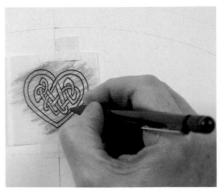

4 Trace the heart motif from the template (page 125) and carbonize the back before placing it on the center line ¾in above the horizontal line, transferring the design to the card.

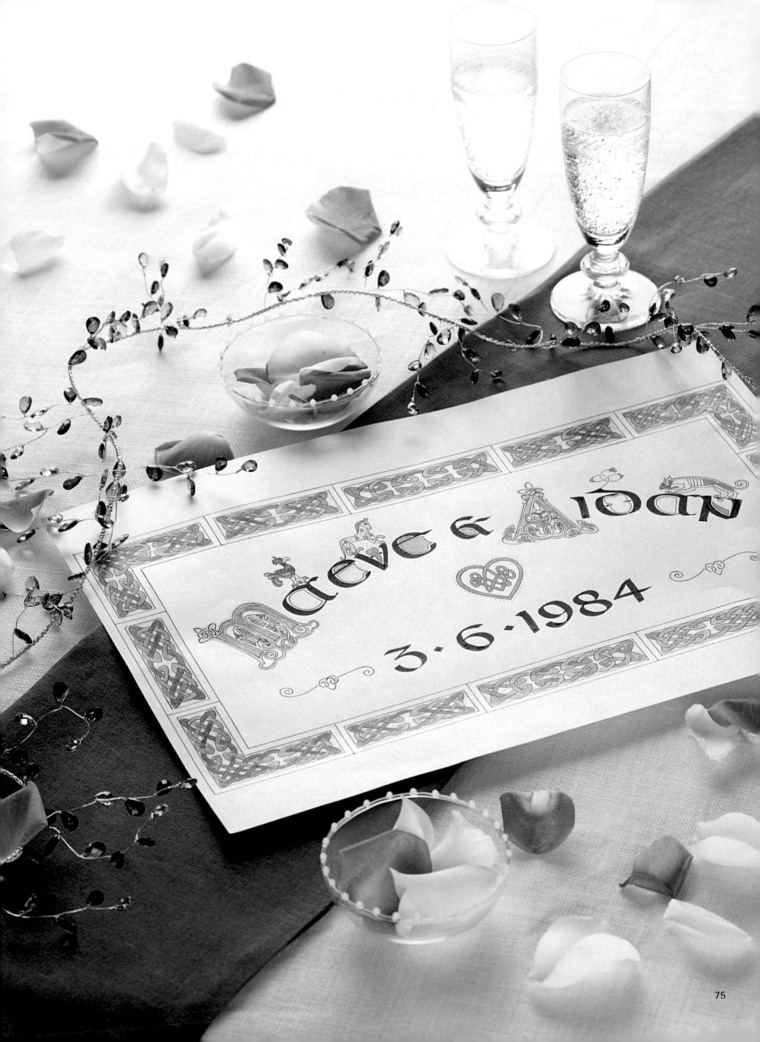

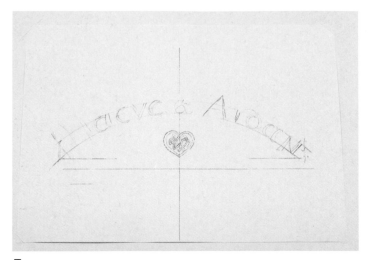

5 Very lightly plot the letters freehand in pencil between the curves, spacing them so that the first and last letters match horizontally.

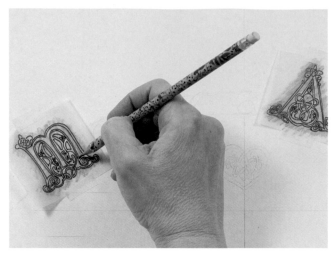

6 Trace the caps from the template (page 125) or draw your own onto a sheet of tracing paper then center the cap across the writing lines at the left-hand extremity of the curves and transfer the design.

Tip

● When using a combination of templates take care to position each one correctly.

● To give your flexible curve an even curve, bend it around a dinner plate, stool seat, table edge, or any other large rounded object.

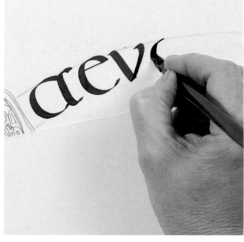

7 Write the letters of the names onto the card, using the pencil marks as a guide.

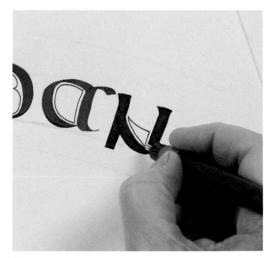

8 Take the fine-line black pen and go over the pencil cap letters and draw the outlines of the decoration inside the letters.

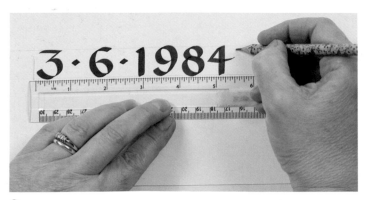

9 Draw horizontal writing lines on a practice sheet and write the date, then measure the length.

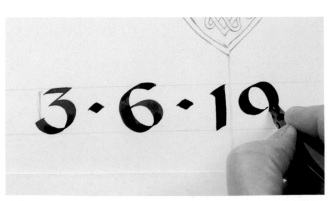

10 Transfer the length to the card, centering it on the vertical line then begin writing in the date in ink.

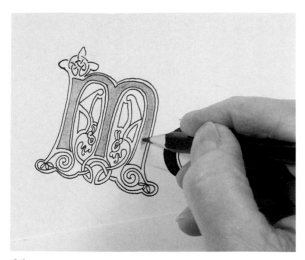

11 Use color pencils to add color to the capped letters and the letter decoration.

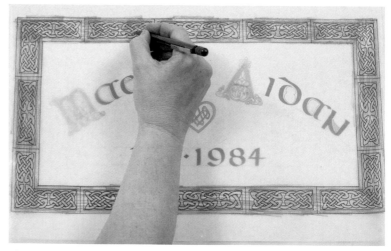

12 Take the traced frame, carbonize the back and transfer the design onto the card, centering it around the design. Allow space above the names to add in zoomorphic decoration.

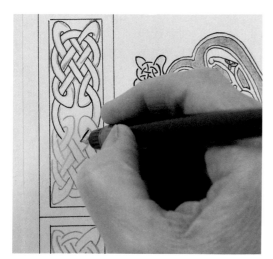

13 Go over the pencil with the fine-line black pen.

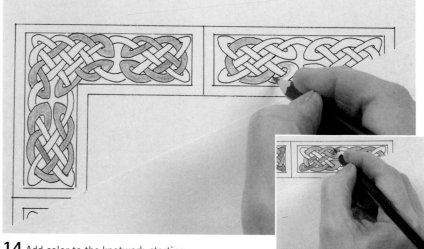

14 Add color to the knotwork, starting with light purple and continuing in dark purple, green, and yellow.

15 Trace the zoomorphic animals (page 125) and transfer them to the main sheet. Finish by adding decoration around the date and color to the heart and animals.

Celtic Bookmark

With this Celtic astronomical blessing of the Sun, Moon and stars, this bookmark will

always be useful to keep your place in your favorite book. It is written in Irish Gaelic

and topped with a Celtic cross motive, which in Celtic Christian times represented

great spirituality and protection.

Materials

Craft knife or scissors
Cutting board
Watercolor card
Fine-line black pen
2B and H pencils
Tracing paper
Size 0 brush
Pearlized turquoise ink
Palette
Red and dark green
 waterproof ink
Water jar
Gum arabic
Cartridge paper
Size 3 brush for mixing
Size C5 nib and reservoir
Pen holder
Hole punch
Tartan ribbon (12in)

1 Cut a rectangular bookmark from the sheet of watercolor card then draw a border ⅛in around the edge with a fine-line black pen, leaving ½in from the top of the card to allow for the ribbon hole.

2 To position the Celtic cross centrally, measure the width of the card and mark the middle with a pencil. Draw a line, allowing space for the Celtic cross and then continue marking a pencil line in the middle.

3 Trace the design from the template (page 122) or design your own Celtic cross. Carbonize the tracing and transfer to the card with a sharp, hard pencil.

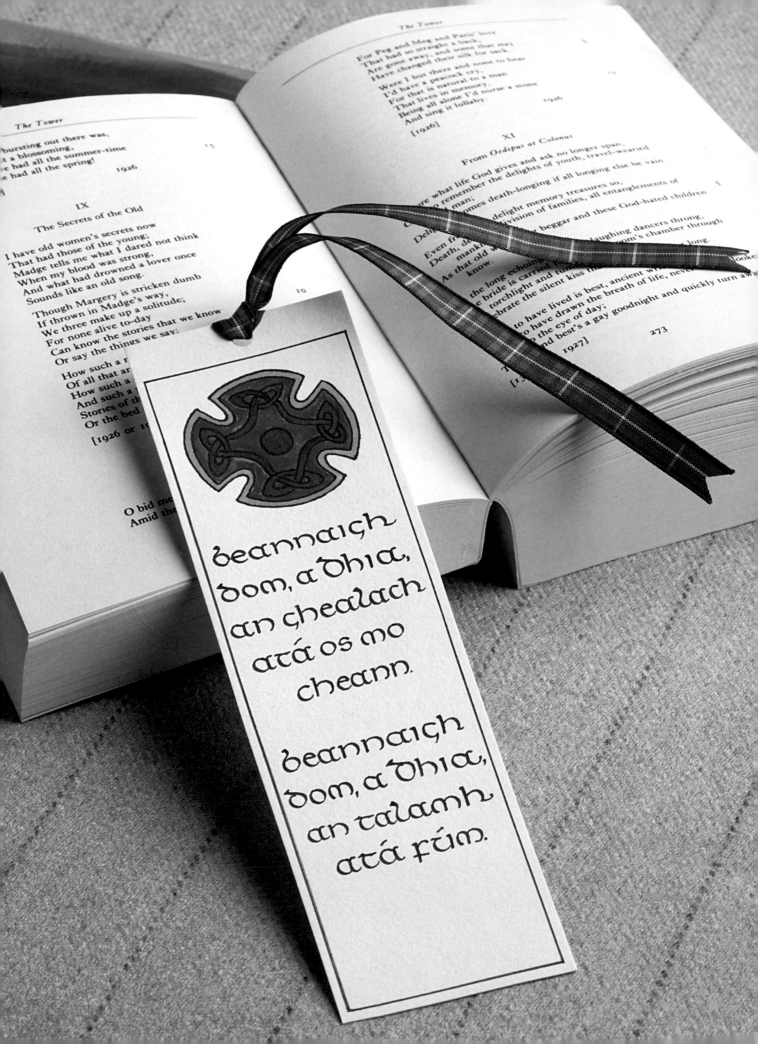

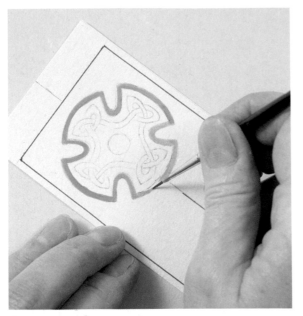

4 Use the size 0 brush with the turquoise pearlized ink, to paint the outside edge of the design.

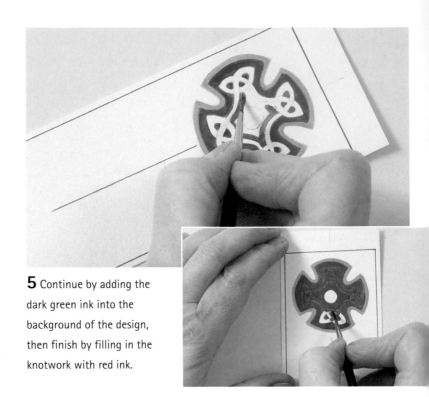

5 Continue by adding the dark green ink into the background of the design, then finish by filling in the knotwork with red ink.

Deannaich dom, a Dhia, an chealach atá os mo cheann

Deannaich dom, a Dhia, an tal

6 Rule a sheet of cartridge paper with two staves using the size C5 nib and write out the verse. At this stage just practice forming the letters, do not worry about fitting the words onto the bookmark.

7 Cut out the calligraphy from the practice sheet and lay it on a spare bookmark to discover the ideal position and length of each line.

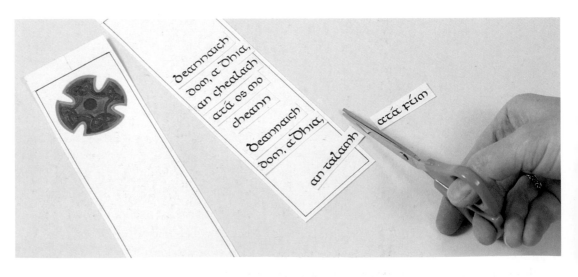

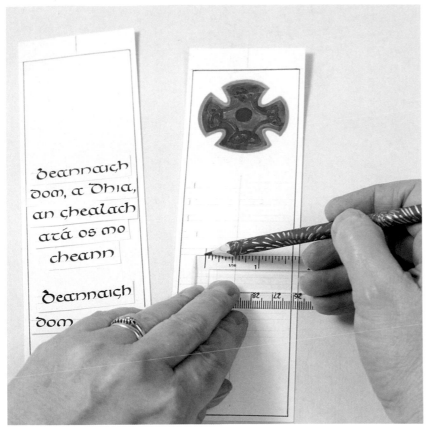

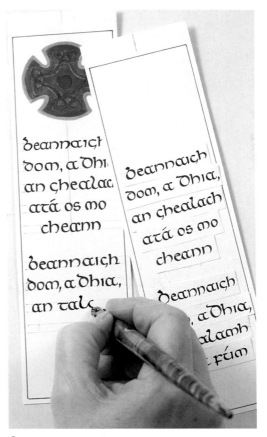

8 Rule up staves on the bookmark and measure the length of each practice line. Center each measurement, marking the start of each line of text.

9 Write the blessing onto the bookmark using the same nib as the practice sheet.

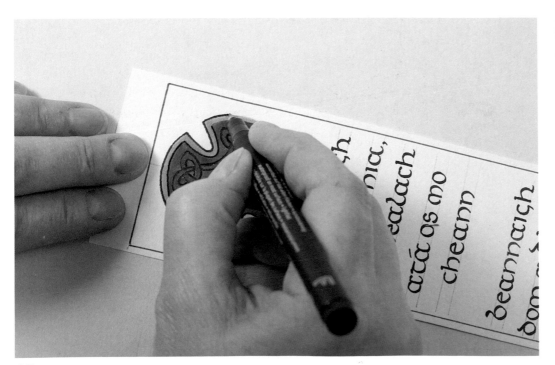

10 Use the fine-line black pen and go over all the lines, adding some dots around the cross then, when everything is dry, erase the pencil lines, and punch a hole through the top of the bookmark, adding the tartan colored ribbon.

Deannaigh dom, a Dhia, an ghealach ata os mo cheann.

Deannaigh dom, a Dhia, an talamh ata fum.

Bless to me, O God, the moon that is above me.

Bless to me, O God, the earth that is beneath me.

Chinese Proverb

All Chinese proverbs have an ancient wisdom at their heart, and this is no exception:

"Rather light a candle, than complain about the dark." This project uses a silver

candle-shaped design of an interlacing Celtic knotwork panel, whilst the first line of

the proverb is written in an arc and depicts the glow from the candle flame.

Materials

Compass
H and 2B pencils
A3 dark blue paper
Gold and silver metallic
 fiber pens
A4 tracing paper
Pen holder
Size C4 nib and reservoir
Silver and gold metallic
 ink
Size 0 brush

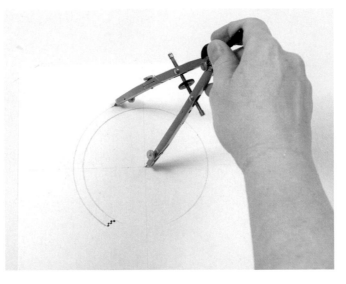

1 On a practice sheet draw a center line down then mark 3½in down and draw a horizontal crossing line. Set the compass to 2in and place on the crossing point. This is the writing line. Draw a stave out from this line using a size C4 nib then recalibrate the compass on the outer edge of the stave to make the upper writing line.

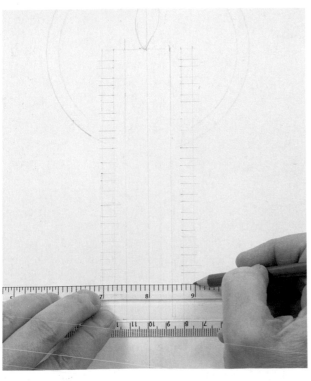

2 Draw a horizontal line 1in either side of the mark made in the previous step to form the top of the candle and three vertical lines ½in, ¾in and 1in from the center to form the sides of the candle and two writing columns. Mark the columns with ¼in spaces for the letters divided by ⅛in gaps with ⅝in gaps between the words on the left-hand column and ¾in gaps between the words on the right-hand column, leaving space at the bottom for a knotwork decoration.

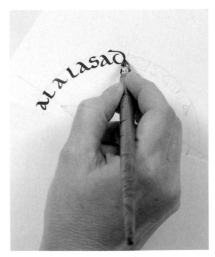

3 Practice writing the Uncial lettering around the circular stave. Very lightly pencil in the lettering and draw a horizontal line to confirm the start and end are level then rewrite in ink using the size C4 nib.

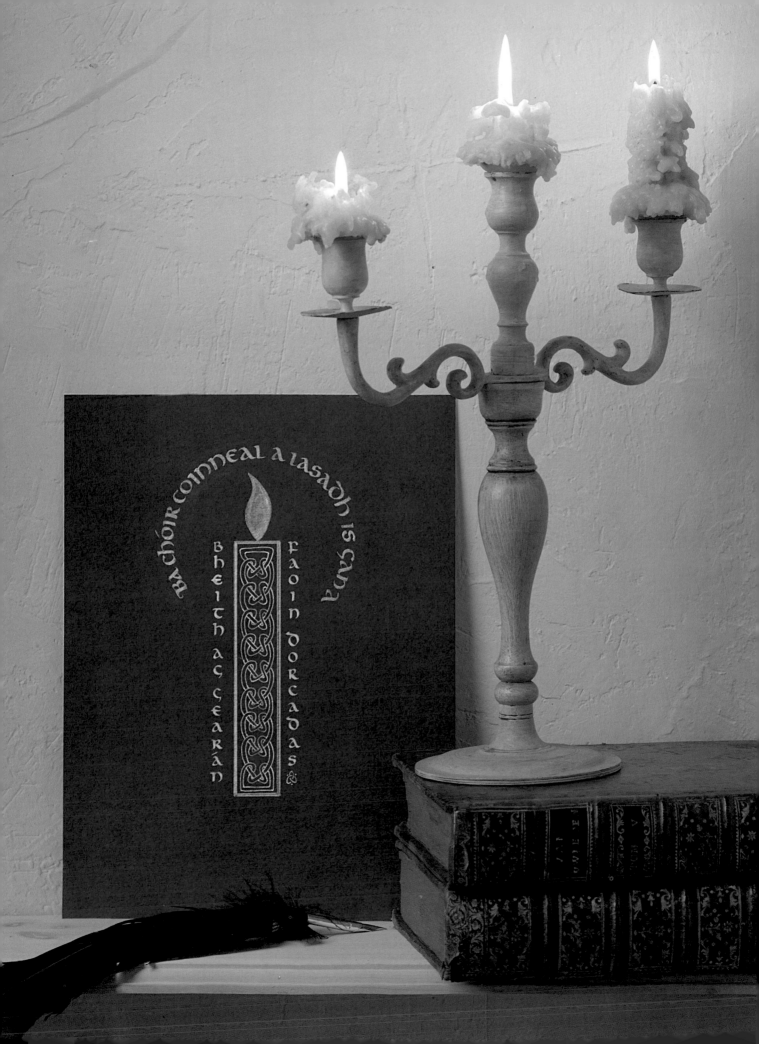

BA CHÓIR COINNEAL A LASADH IS CANA

BHEITH AG GEARÁN FAOIN DORCADAS

4 Replicate the pencil lines on a piece of card and draw round the candle with a thick-ended gold fiber pen.

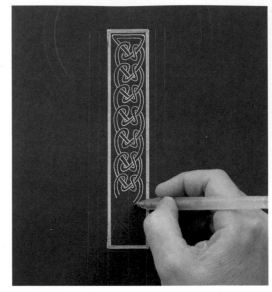

5 Transfer a tracing of the knotwork decoration (page 120) into the center of the candle and cover with a fine point silver metallic pen.

Tip

● Keep metallic ink well-stirred to stop it separating with the water rising to the top. Use a fine brush to place the ink onto the nib.

● After using metallic ink be very careful when erasing pencil lines as the ink smudges easily.

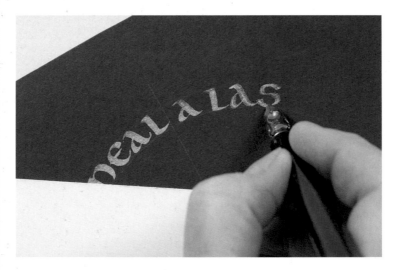

6 Write the circular lettering using metallic gold ink.

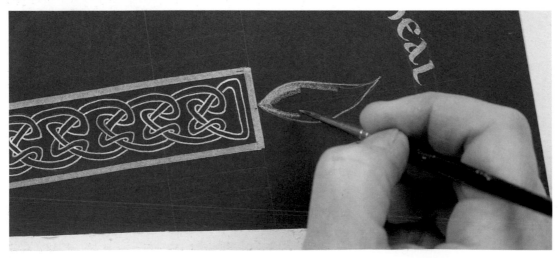

7 Draw the outline of the flame in pencil then fill in with gold ink using a fine size 0 paintbrush.

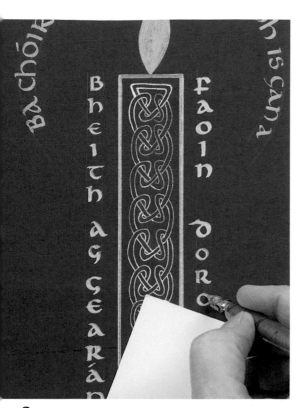

8 Write the columns of text using metallic silver ink with the size C4 nib.

9 Add the final decoration at the bottom of the right-hand column with the fine silver pen.

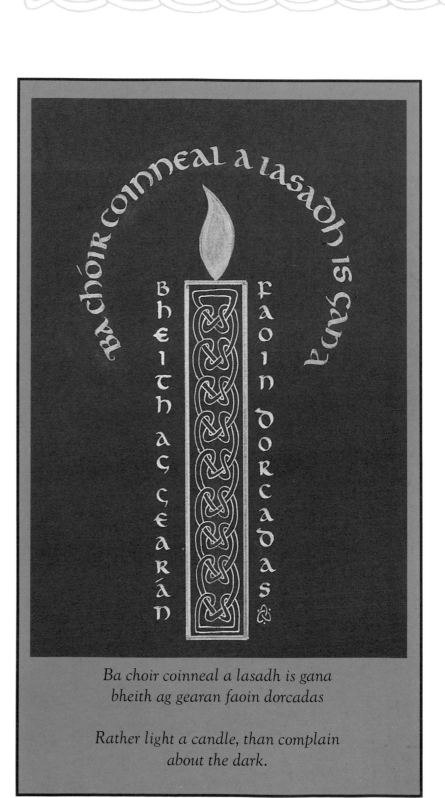

Ba choir coinneal a lasadh is gana
bheith ag gearan faoin dorcadas

*Rather light a candle, than complain
about the dark.*

Monogram Lampshade

Here is an inventive idea for your home—a stamped monogram lampshade with either

your initials, or the initials of you and that special person in your life, entwined.

Introducing the craft skill of cutting a lino board, you will learn to make a stamp which

can be used on a number of objects, such as personalized stationery.

Materials

Lino board

Cutting board and
 craft knife

12in metal-edged ruler

Cartridge paper

Tracing paper

H and 2B pencils

Lino-cutting tools
 and handle

Fabric paints—blue,
 violet, silver, and yellow

Size 1 and 3 brushes

Palette

Water jar

Masking tape

Neutral colored
 lampshade

1 Cut the lino board into smaller pieces with a craft knife and metal-edged ruler. Make sure it is big enough to take your design with a margin of ½in to the edge of the lino board.

2 Trace the initials from the alphabet (page 22). Alternatively, write your own on a sheet of cartridge paper and trace from this. Then, because the stencil is a reversed image, carbonize the front of the design and place it upside down on the lino board before transferring the design with a hard pencil. Repeat with the triskele design (page 117).

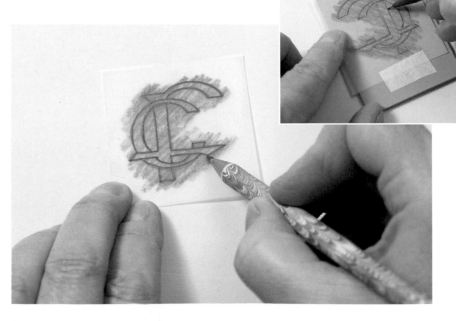

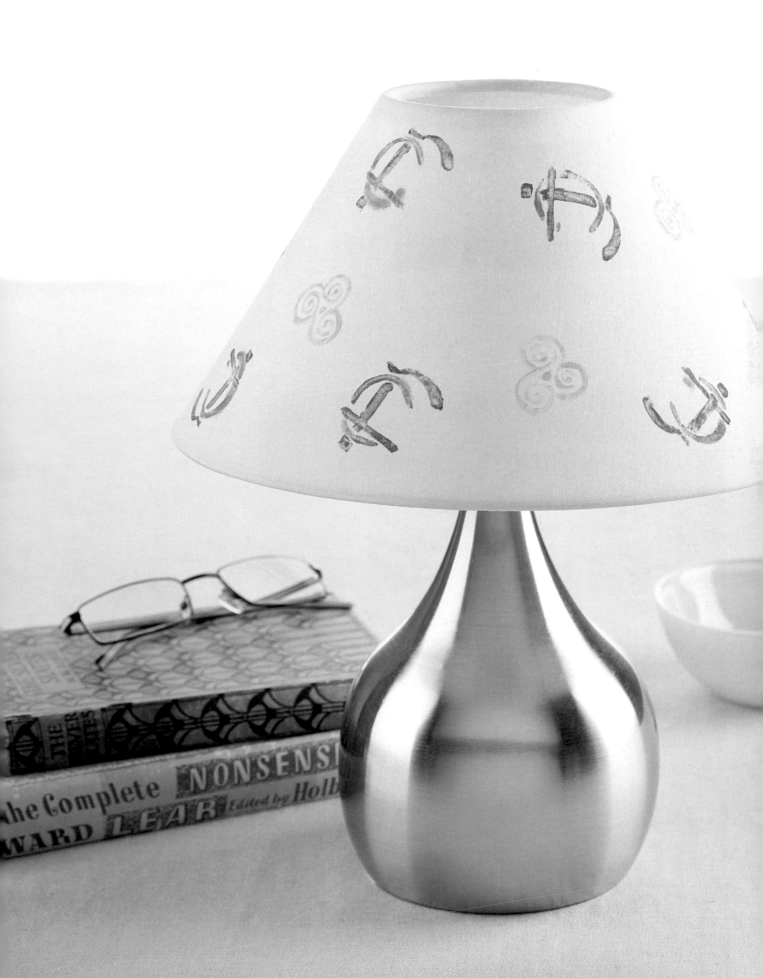

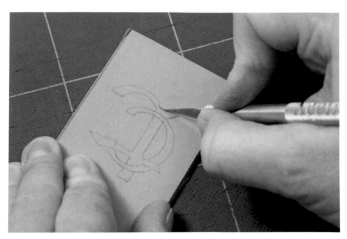

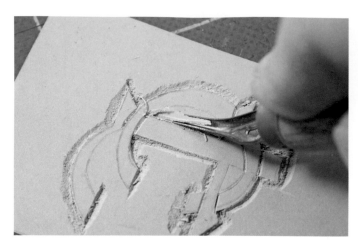

3 Begin cutting the pattern by making a single incision along the pencil lines with a craft knife. Ensure the tip of the blade goes through the hard surface about halfway to the hessian backing.

4 Place the small V-shaped blade into the handle of the lino-cutting tool and cut very slowly and carefully along the outside of the pencil lines. Use firm pressure but do not cut too deeply at this stage. Cut slowly all the way round the design—a mistake at this stage will ruin the stencil.

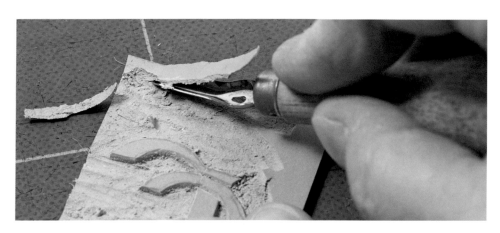

5 Swap the V-shaped blade for a wide curved blade to remove the mass of excess lino around the stamp. You need to take out all the lino board right to the edges. Try to have clean cut lines as the stamp will work much better. Next, cut off the corners of the stamp so that it fits comfortably into the hand.

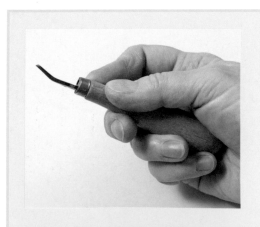

To use the lino-cutting tool effectively, press the base of the wooden handle into the palm of the hand and wrap your fingers around it so that you have a firm but comfortable grip.

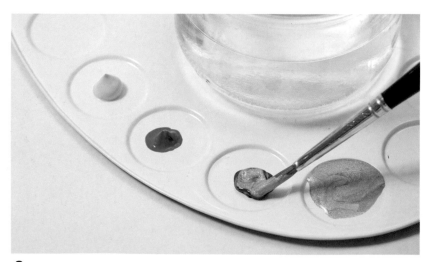

6 Now mix the fabric paints with a little silver paint to give them some sheen. Take the size 3 brush and place some purple in the palette, adding only a drop of water and some of the silver paint. Mix together. Repeat with the blue and yellow colors, mixing each well.

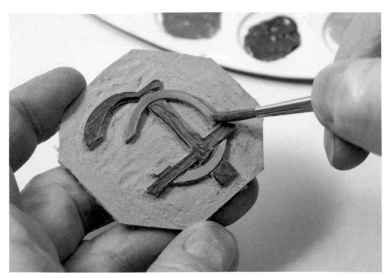

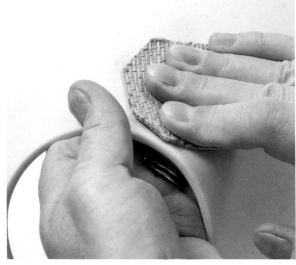

7 Use the size 1 brush to paint the colors onto the initials. Apply a little of the blue paint and then the purple evenly to the cut initials, using one color for each letter.

8 Now print onto the lampshade. Hold the inside of the lamp with your left hand as a support and press firmly straight onto the shade with your right hand, keeping the stamp as flat as possible to the surface.

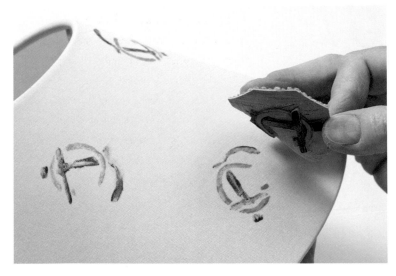

9 Reapply the two paint colors each time you use the stamp. Lift it away smoothly, making sure not to smudge the initials you have just stamped.

> **Tip**
>
> Use a round-handled craft knife to cut the lino as it is more difficult to create smooth corners with a straight-bladed knife—and also more uncomfortable on the hand.

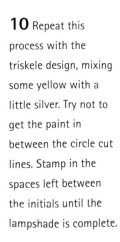

10 Repeat this process with the triskele design, mixing some yellow with a little silver. Try not to get the paint in between the circle cut lines. Stamp in the spaces left between the initials until the lampshade is complete.

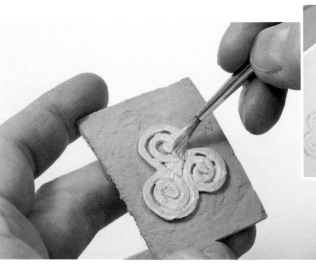

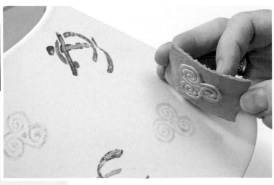

Wooden Christening Plaque

This unusual christening plaque uses metallic inks painted on a round wooden plaque,

and a Celtic knot panel to illustrate eternity with no beginning or end.

The Gaelic word "Failte" means "welcome."

Materials

Wooden plaque (8in)

Fine sandpaper

Matt varnish

Flat varnish brush

Tracing paper

H and 2B pencils

Size 0 brush

Pearlized yellow, violet, and green ink

Fine-line black pen

12in ruler

Cartridge paper

Compass

Pen holder

Size C2 and C3 nibs

2 ink reservoirs

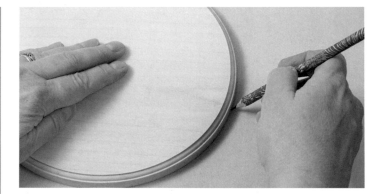

1 Before writing, sand down the front of the plaque and varnish it before leaving it overnight to dry. Mark the outline of the plaque on a sheet of tracing paper then trace the template of the round Celtic knot border (page 123), enlarging or reducing its size to fit if necessary.

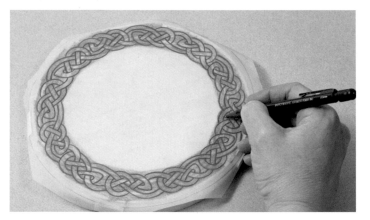

2 Carbonize the back with the 2B pencil then stick in place with masking tape and use the H pencil to go over all the border.

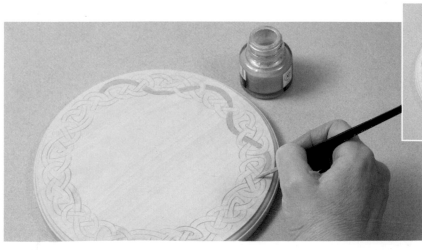

3 Now take a size 0 brush and paint the unknotted ribbon with yellow pearlized ink, taking care to go over and under the other ribbons in turn. Make sure you keep stirring the ink to mix it well during the painting. Follow with the violet, and then the green ink. Allow to dry.

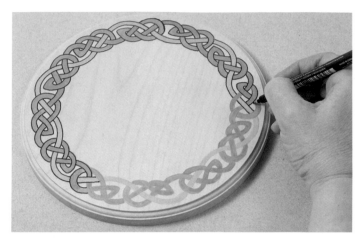

4 Go around all the borders with the fine-line marker pen to emphasize the colors, again checking the over and under movement of the Celtic design.

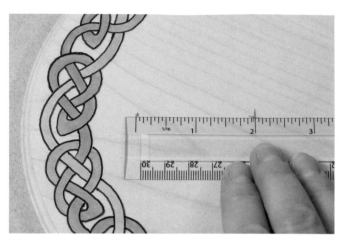

5 Find the center point on the plaque and mark it with a cross. Draw a small pencil line with the 2B pencil to a point ³/₄in from the border and measure this distance.

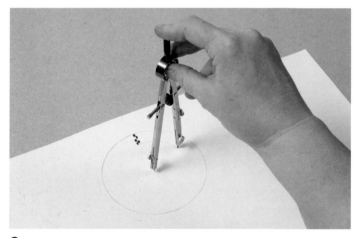

6 Now take a sheet of cartridge paper and draw a circle with a compass of the same radius as previously measured. Then, with a pen and a size C2 nib, draw 4½ pen widths down from the pencil line and draw a second circle with the compass to create a circular writing stave.

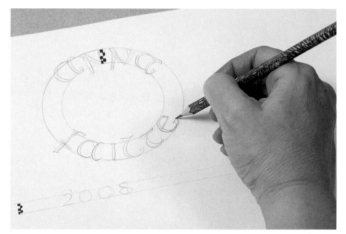

7 Use the 2B pencil to practice the spacing of the Half-uncial lettering. Make the two initial letters—A and F—slightly larger than the rest. Also create a flat stave with the size C3 nib and practice writing the date.

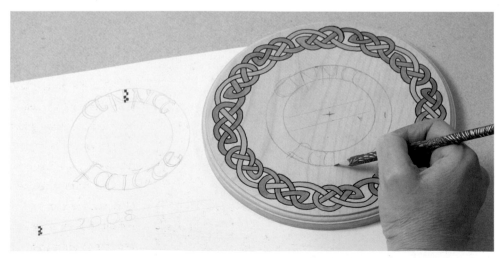

8 Repeat the previous step on the plaque, drawing in the stave and lettering in pencil, taking care to center both words in relation to the horizontal date line.

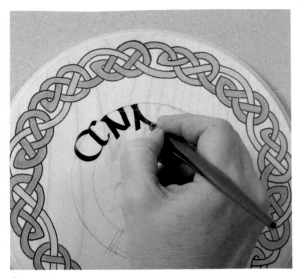

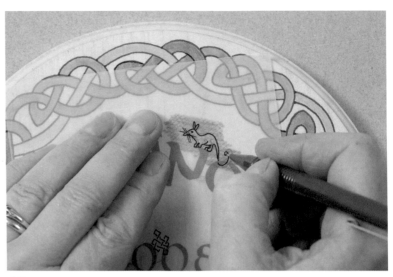

9 Now write the words in ink using the size C2 nib and reservoir, ensuring the initial letters are slightly larger than the rest. Allow to dry before writing the date with the size C3 nib. Again, allow to dry.

10 Trace the templates of the two animal decorations (page 123) and carbonize as before, placing them on top of two of the letters.

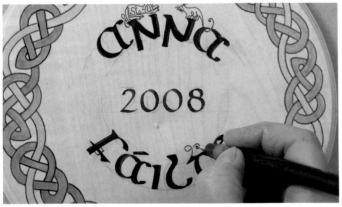

11 Draw the animals in with the fine-line black pen and add decoration to some of the other letters.

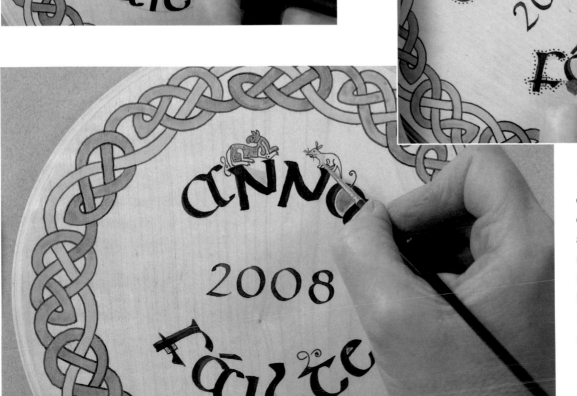

12 Paint the animals with colored ink and also add color to some of the letters at this stage. To finish, rubrify the two initial letters using the fine-line black pen, erase any remaining pencil marks, and varnish the plaque.

93

Zoomorphic Letter

Based on the Irish Half-uncial alphabet dating from the fine manuscript books of the

seventh and eighth centuries, this illuminated letter B incorporates a traditional animal

design, known as a zoomorphic.

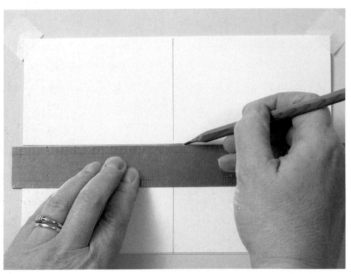

1 Fold the card in half lengthwise then find the center of the card by lightly drawing lines down and across the card with the soft pencil.

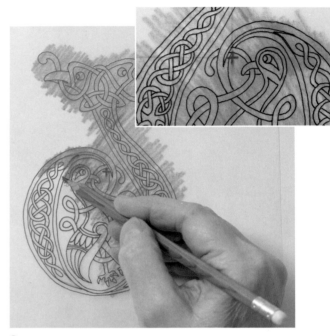

2 Transfer your letter B from the template (page 118) onto a sheet of tracing paper, or draw your own designed letter. Turn it over and carbonize the back with a soft pencil. Turning it right way round, center the letter on the card using the pencil lines to guide you and stick it down with masking tape.

Materials

Sheet of off-white card

12in ruler

H and 2B pencils

Tracing paper

Masking tape

Eraser

Gouache colors

Palette

Water jar

Gum arabic

Size 1 brush

Fine-line black pen

Fine-line red pen

3 With a hard pencil go over the letter, transferring the design to the card.

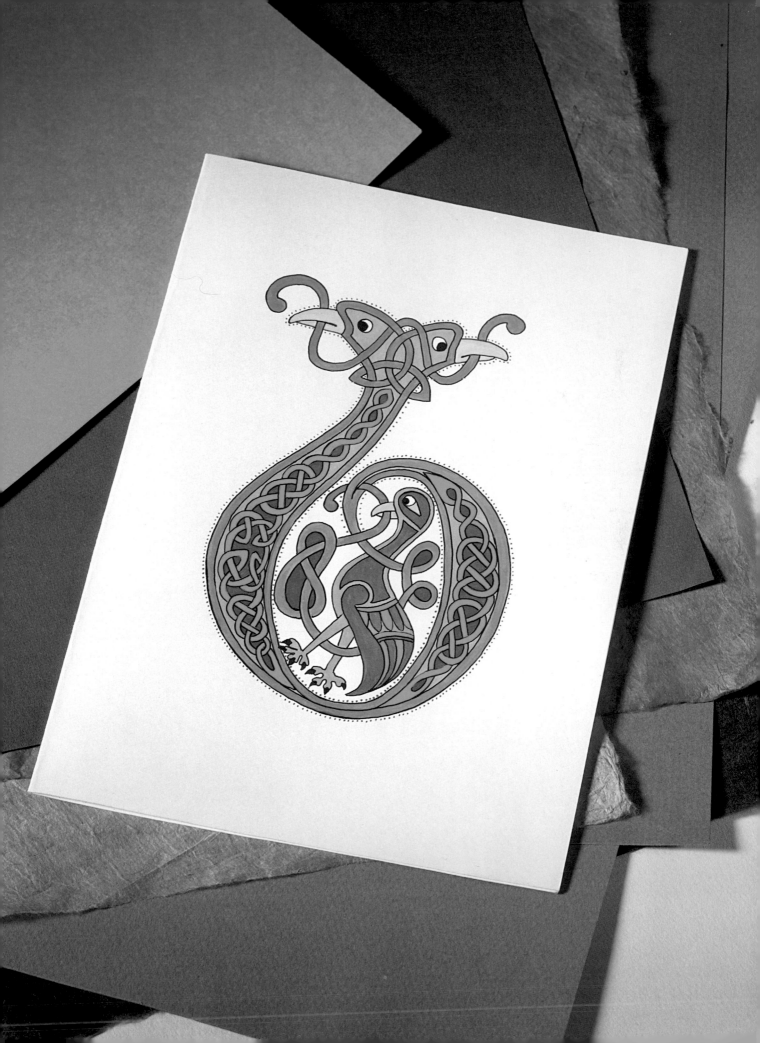

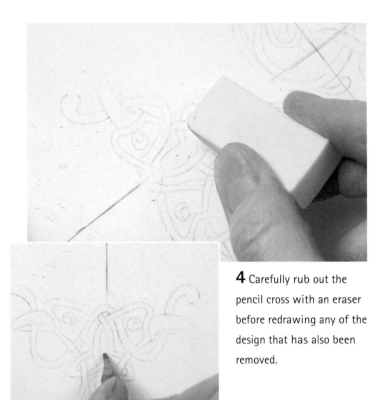

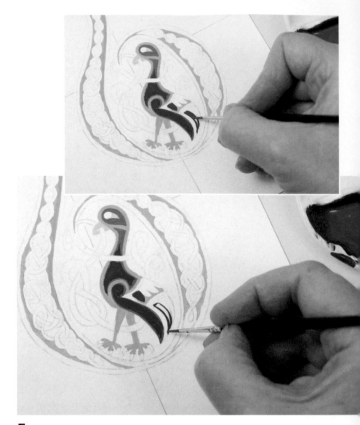

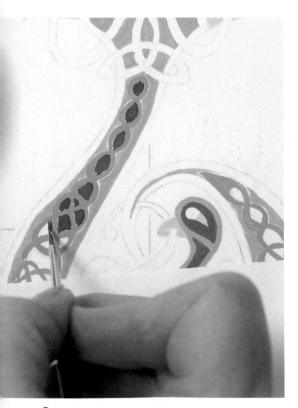

4 Carefully rub out the pencil cross with an eraser before redrawing any of the design that has also been removed.

5 Now paint the letter using the gouache colors. Mix a little paint in the palette with a drop of gum arabic and water until it is the consistency of single cream. Use the size 0 brush to paint along the pencil lines then fill in the rest of the color. Work in this method for each section and each color.

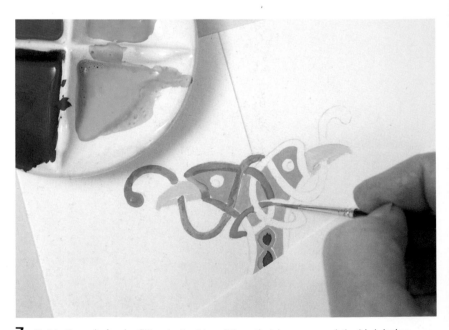

6 When each color is dry, mix the next and work into the design. Use progressively darker colors so that any mistakes can be hidden by the neighboring shade.

7 Finish the coloring by filling in the blue ribbon that loops around the bird design.

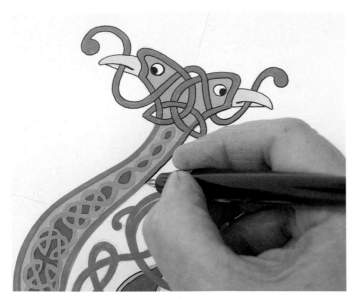

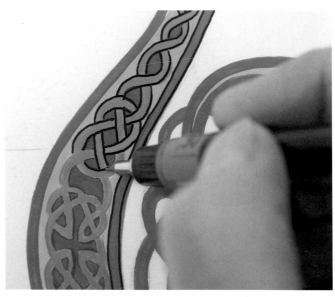

8 Outline the design with the fine-line black pen to solidify the colors and make each section stand out.

9 When outlining the knotwork, take special care to ensure that the ribbon never goes over or under two consecutive elements. If necessary have the template to hand as a guide.

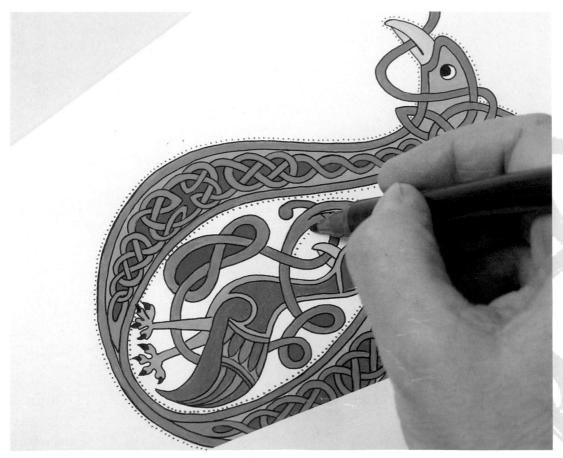

10 To finish, add either red or black dots around the outer edge of the letter with a fine-line pen.

Rainbow Alphabet Book

This little concertina alphabet book will help children learn their letters in a fun way.

Adding gouache to the pen nib without washing each previous color off the nib creates

a smooth flow of color from page to page.

1 Cut an A3 sheet into six strips each 3in wide. Find the position of the letters by drawing lines along the length of the strip ¾in from top and bottom then mark divisions every 3in. Now measure ¾in on both sides of these divisions, creating squares for each letter.

Materials

Cream parchment card
12in ruler
Cutting board
Craft knife
Automatic pen
Gouache color—scarlet,
 ultramarine, bright green,
 yellow, purple, and white
Large palette
Water jar
Gum arabic
Size 1, 2 and 3 brushes
PVA glue
Tracing paper
3 x 20in ribbons
Marbled paper
H and 2B pencils
Fine-line black pen

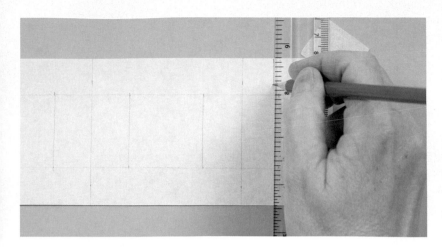

2 The squares will not reach along the length of the strip so mark 1in from the end of the last letter space and draw a line, then cut along it with a craft knife.

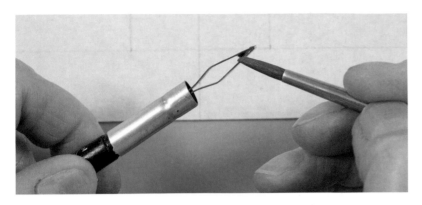

3 Start painting in the third space. Add scarlet paint to the automatic pen with a paintbrush, stroking the brush tip across the V shape, filling the inside of the pen with paint.

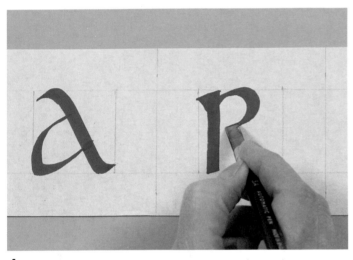

4 Let each letter fill the square. For the next letter (the "B") add some yellow to the red gouache remaining in the automatic pen to create a mixed orange color.

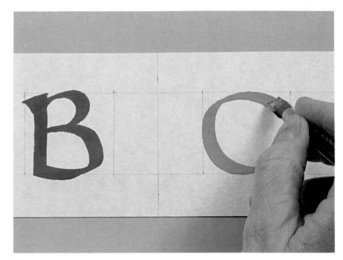

5 Apply more yellow gouache to the nib for the "C" so that the color is almost pure. Continue until all 26 letters have been painted.

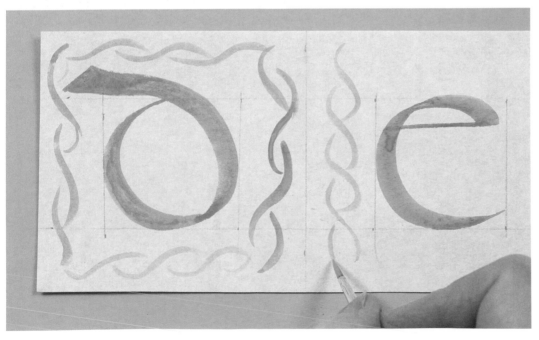

6 Use a size 1 paintbrush to add a border around each letter, freehand, matching the color combinations of the letters.

7 Fold over the end line and and cover it with PVA glue then stick the lengths of letters together. Concertina the long strip, folding over the card along the pencil lines.

8 When all the strips are connected fold the card into a concertina, pressing along the pencil lines that divide the letters.

9 To create the cover designs, trace the knotwork from the template (page 124) and carbonize the reverse, transferring the design onto marbled paper. Work heavily to ensure the pencil shows up on the marbled paper.

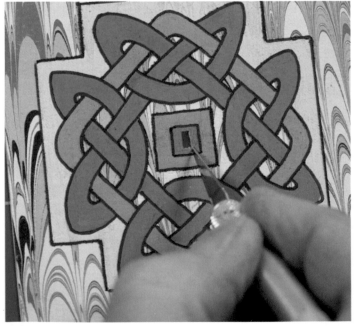

10 Go over the pencil on the marbled paper with a black pen then paint in the blocks of color with a size 2 paintbrush.

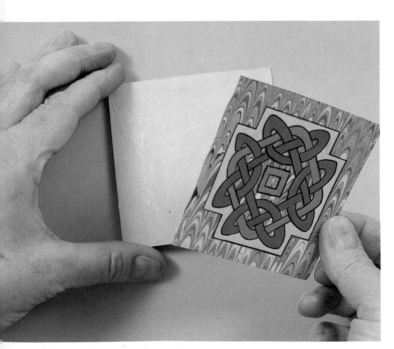

11 Use PVA glue to stick the marbled paper to a piece of card cut to the same size.

12 When it is dry cut a hole in the center with a craft knife to enable the ribbons to be inserted.

13 Thread the three ribbons through the hole, flatten them, and stick the ends down onto the back of the card then cover all of the card with glue.

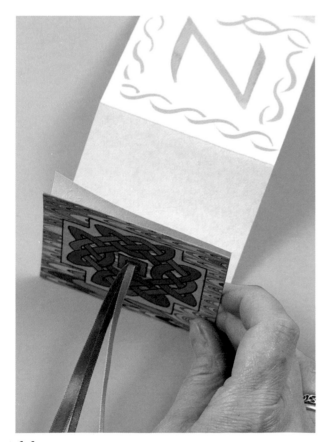

14 Stick the marbled card onto the back of the concertina, so that the ribbons align with the concertina. Create a second marbled card without a hole or ribbons and stick it onto the front of the card. Tie the ribbon around the folded book.

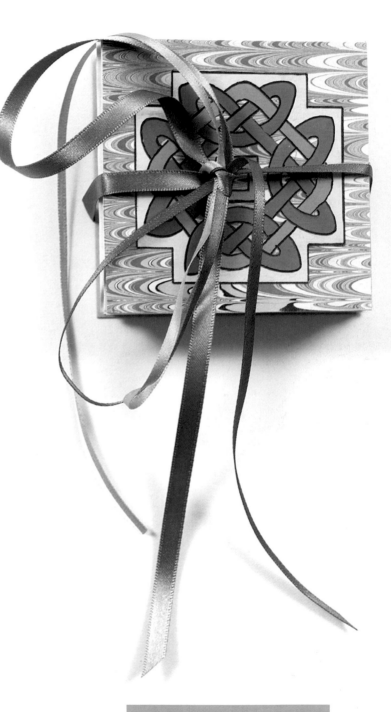

Tip

Rather than making a book, you could display the strip of letters in a frame to decorate a child's bedroom wall.

Garden Seed Box

This inventive gift for seed collectors can be made from any size cardboard box and some

paper. On the top, it reads "garden seed" in Gaelic, written in Irish Half-uncial script.

Around the lid in Latin are flower, herb, and vegetable names.

Materials

6in ruler

Cardboard box with lid

Green card in 2
 shades

Pinking shears

PVA glue

Green parchment card

Compass

White cartridge paper

Size 10 double-point nib

Pen holder

Turquoise ink

H and 2B pencils

Tracing paper

Size 0 brush

Brown and yellow inks

Fine-line gold pen

Fine-line black pen

Calligraphy felt tip
 gold pen

Eraser

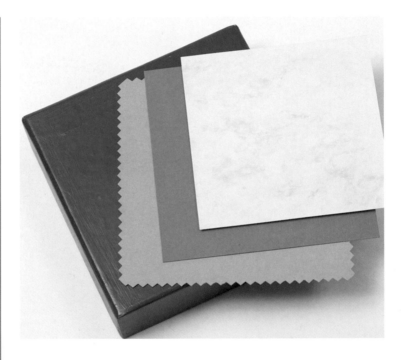

1 Measure the box lid and cut one of the sheets of green card to fit. Use the decorative scissors to cut around the edge, allowing a little of the box edge to show all round. Place onto the lid and stick down with PVA glue. Cut the other green card slightly smaller and stick down on top. Measure the parchment writing card slightly smaller than the last and cut to fit but do not stick it down yet.

2 Find the middle of the parchment by measuring across and down the card and drawing one line across and one down to find the center point. Create the top curved writing line by placing the compass onto the bottom of the middle line and drawing a semicircle about 1in from the top of the card.

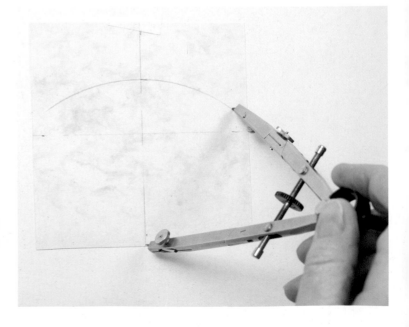

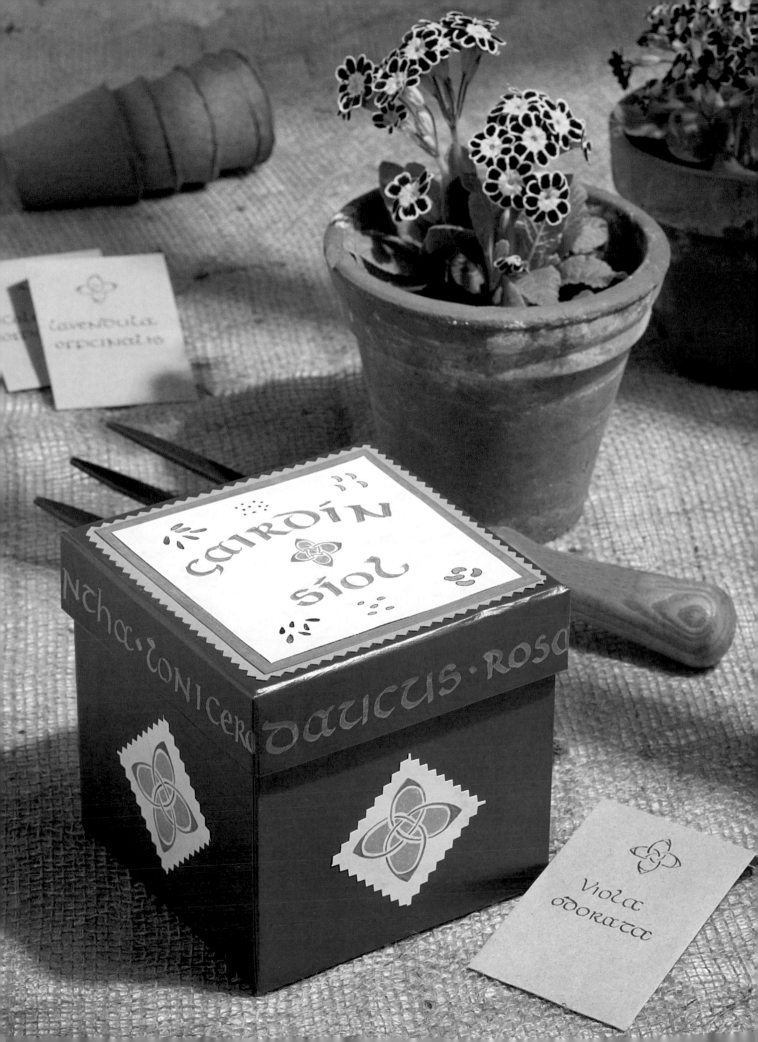

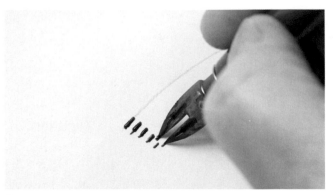

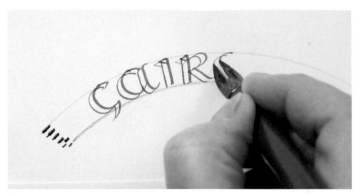

3 Use the compass at the same setting to draw a similar curve on the cartridge practice paper. Draw a 4½ pen-width stave with the size 10 double-point nib using turquoise ink. Recalibrate the compass and draw a second curve from the bottom of the stave, making sure the point is in exactly the same place.

4 Now practice writing the Gaelic word for garden, *gairdin*, keeping the letters upright along the writing line. Turn the paper as you move around the curve so that your writing is always upright.

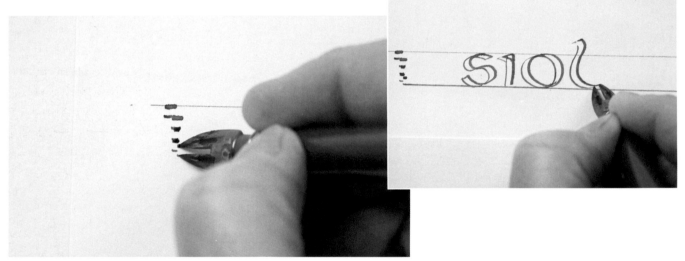

5 Underneath draw a line and make a second 4½ pen-width stave, adding a pencil writing line. Practice writing the word *siol*, meaning seed.

6 On the parchment card add the curved writing line at the top by using the compass spread to the same distance as on the practice sheet, placing the point in the same place as in Step 2. Add the straight writing line 1in up from the bottom of the card. Measure the height of the writing line on the practice sheet and replicate this height on the card.

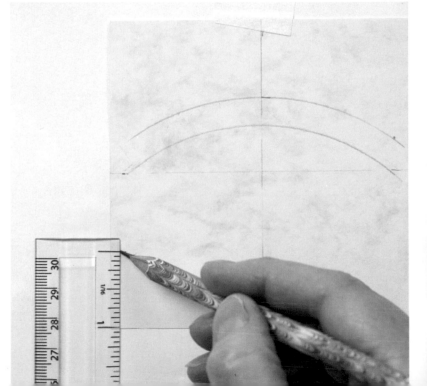

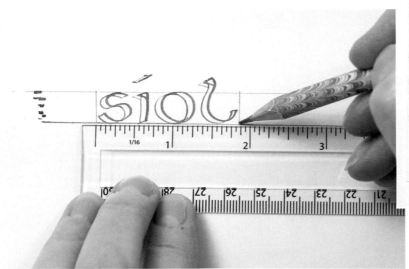

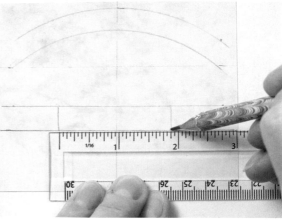

7 Go back to your practice sheet and measure the length of the writing lines and transfer the start point measurement to the green parchment card.

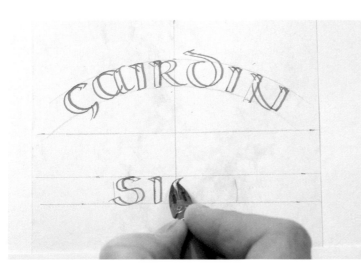

8 Write the card using the turquoise ink and double-point nib, taking care to center the writing along the curved line.

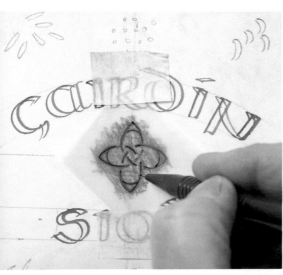

9 Draw the seed shapes, trace the Celtic knot motif from the template (page 117), carbonize the back and transfer it onto the middle of the box lid with a hard pencil.

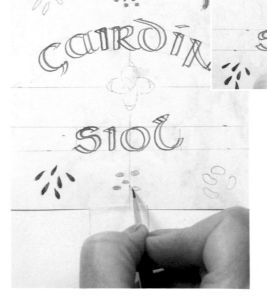

10 Now use a fine brush to paint the seeds with a variety of shades of brown ink and the Celtic motif with turquoise ink.

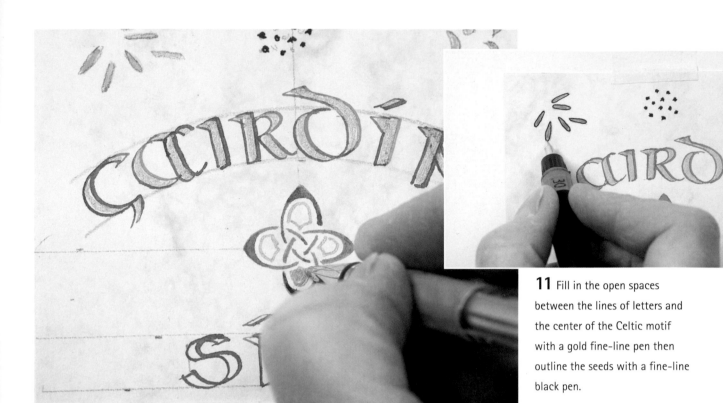

11 Fill in the open spaces between the lines of letters and the center of the Celtic motif with a gold fine-line pen then outline the seeds with a fine-line black pen.

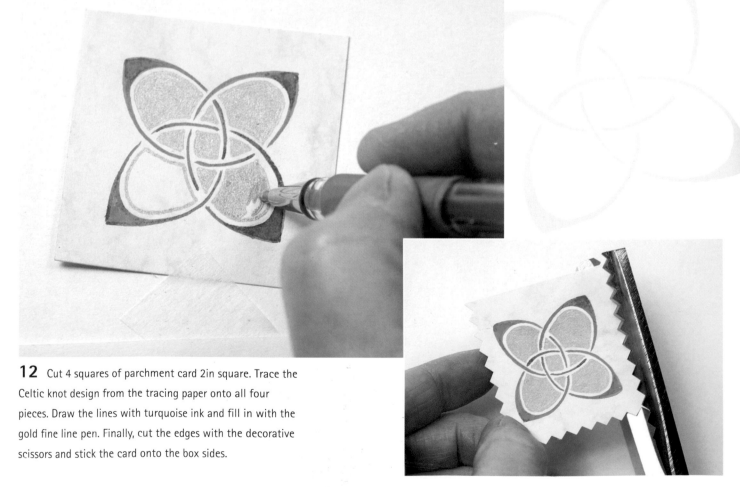

12 Cut 4 squares of parchment card 2in square. Trace the Celtic knot design from the tracing paper onto all four pieces. Draw the lines with turquoise ink and fill in with the gold fine line pen. Finally, cut the edges with the decorative scissors and stick the card onto the box sides.

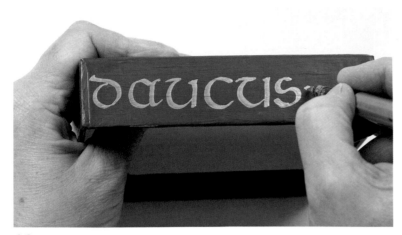

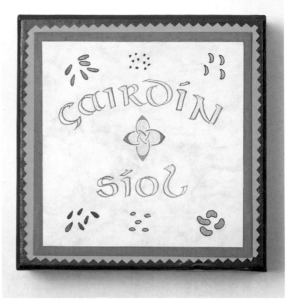

13 Take the gold calligraphy permanent felt tip pen and write the Latin names of plants all the way round the side of the lid, forming a border of words. It does not matter if the word does not finish at the end of the line, just continue to write on the next side of the lid until all is covered.

14 To finish, stick the green parchment card onto the lid on top of the other green shades of card.

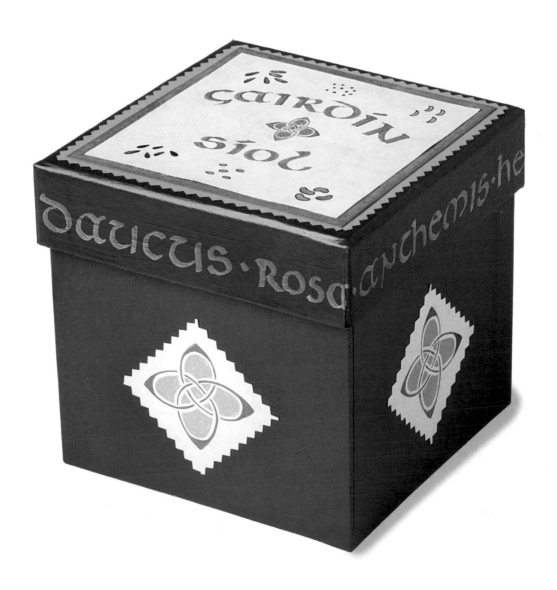

Celtic Jewelry Box

The angular square letters on the lid of the box read "jewelry" in Gaelic and are painted

similarly to the letters in the Irish Book of Kells. Celtic jewelry adorns the box, echoing

ancient Celtic designs—choose any you like from the templates on page 116.

1 Prepare the box by smoothing the lid along the grain with fine sandpaper and varnishing it using long strokes with the flat brush. Allow it to dry overnight. Transfer the decorations and words from the template (page 116) onto tracing paper and cut them out.

2 Carbonize the back of the lettering with the soft pencil before sticking it to the box lid with masking tape and transferring the design with a hard pencil.

Materials

Wooden box

Fine sandpaper

Matt clear varnish

Soft flat varnish brush

Tracing paper

H and 2B pencils

Masking tape

Fine-line black pen

12in ruler

Gouache color—red,
 blue, green, yellow,
 purple, gold, and silver

Eraser

Size 1 and 3 brushes

White spirit

Palette

Water jar

3 Also carbonize the decorations and place them in turn around the lettering, then transfer them to the lid with a hard pencil.

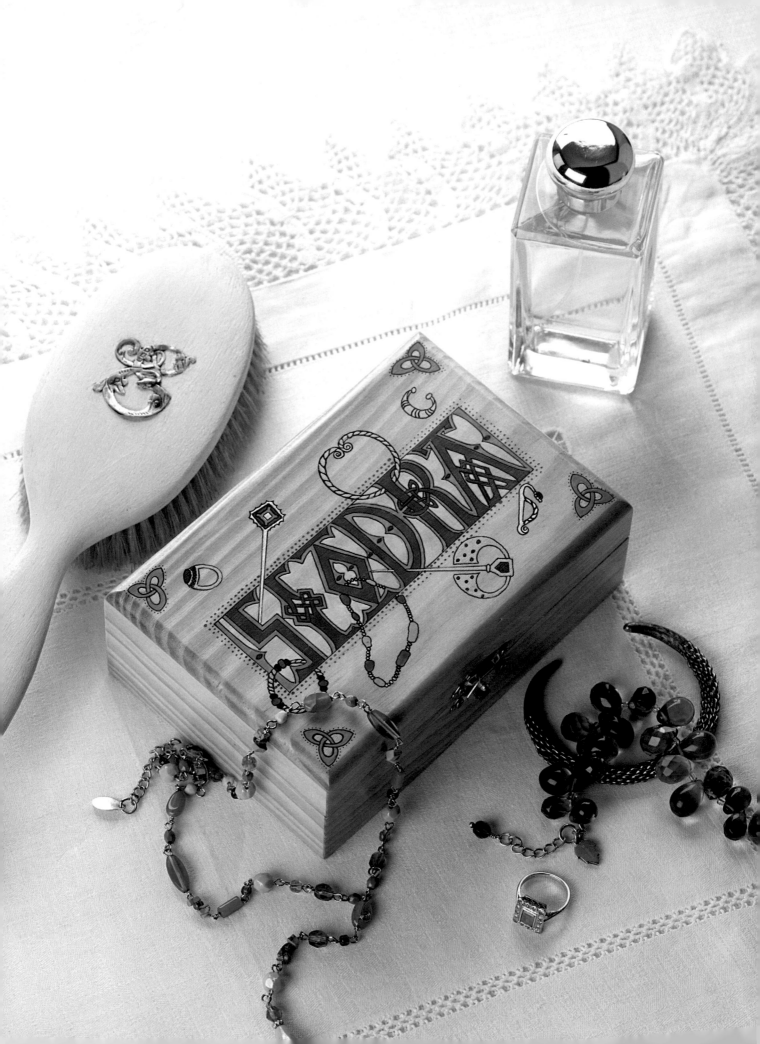

4 Use the fine-line black pen to go over all the pencil lines you have transferred. At this stage incorporate the Celtic jewelry by placing some of it behind the lettering. Remove any pencil lines.

5 Add some gouache color to the word, starting with the yellow background to the lettering. First mark a line alongside the pen line then fill in with color.

6 Continue with the green and red colors of the letters. Let each stage dry before starting the next color.

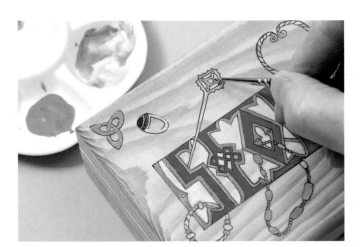

7 Next, paint in the knotwork corners and motifs with colored gouache before finally going around the word panel with two rows of red dots. Also go round the corner designs with a fine-line black pen. Finally, varnish the box to seal the work.

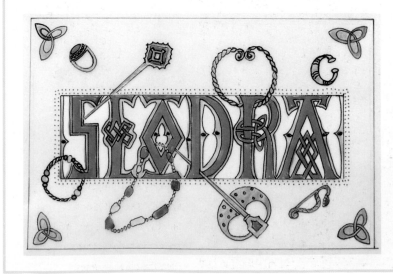

You can use the template as a starting point or, alternatively, design your own decoration on a sheet of paper. When you are happy with the design use it like any of the templates included in this book.

Tip

When tracing intricate designs don't attempt to copy every tiny detail. Once you have transferred the main outline to the box, have the original template to hand and copy the details when highlighting the lines with the fine-line pen.

Rune Stones

Rune stones were used many centuries ago by the people of Scandinavia, who believed

that they held special powers of protection when carried by the owner. Try painting one

of the symbols that you are especially drawn to, to be carried as a talisman.

Materials

White card for practice
Size 1 brush
Enamel paints—red, light
 blue, yellow, green,
 purple, and dark blue
25 white pebbles
White spirit

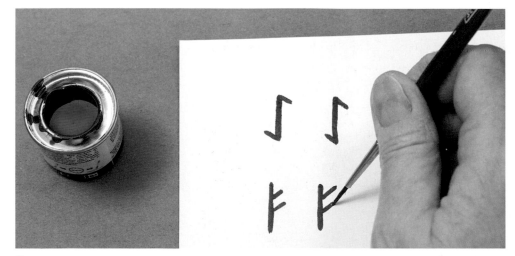

1 Using enamel paint and the size 1 brush, practice painting the runes on the white card. Stir the paint well then work freehand with no ruling up. Start by painting the upright strokes, then the diagonal strokes.

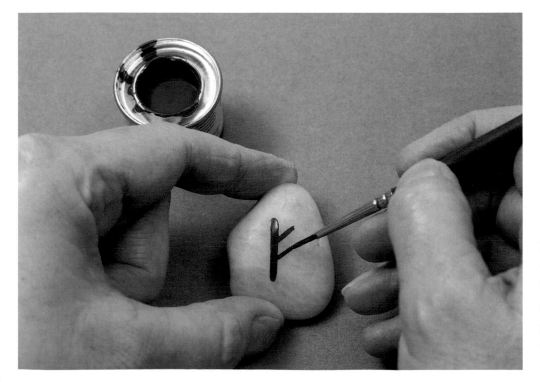

2 Wash the stones in soapy water and allow them to dry before you begin painting the symbols. Use one color to paint four of the runes. Again, paint the upright strokes first, then the diagonal lines.

113

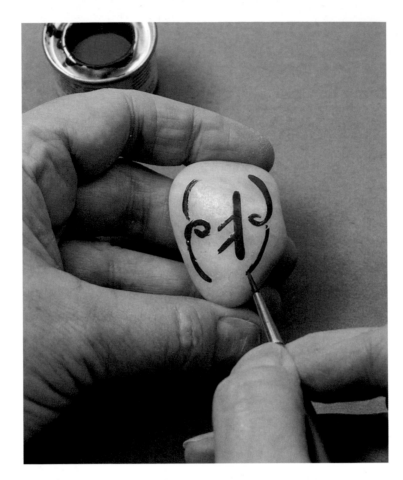

3 Then paint the side decoration, also freehand. Start the right-hand side decoration at the top, painting down the pebble to the bottom. Then turn the pebble round and paint the other side so that you always turn the brush clockwise.

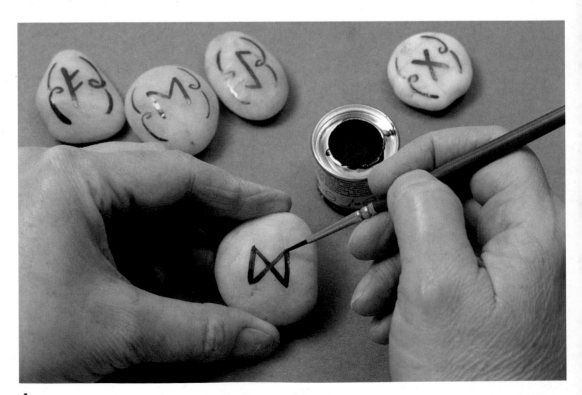

4 Wash the brush in white spirit, and then do the same with each color until you have painted all the stones. Leave for at least 24 hours before handling them.

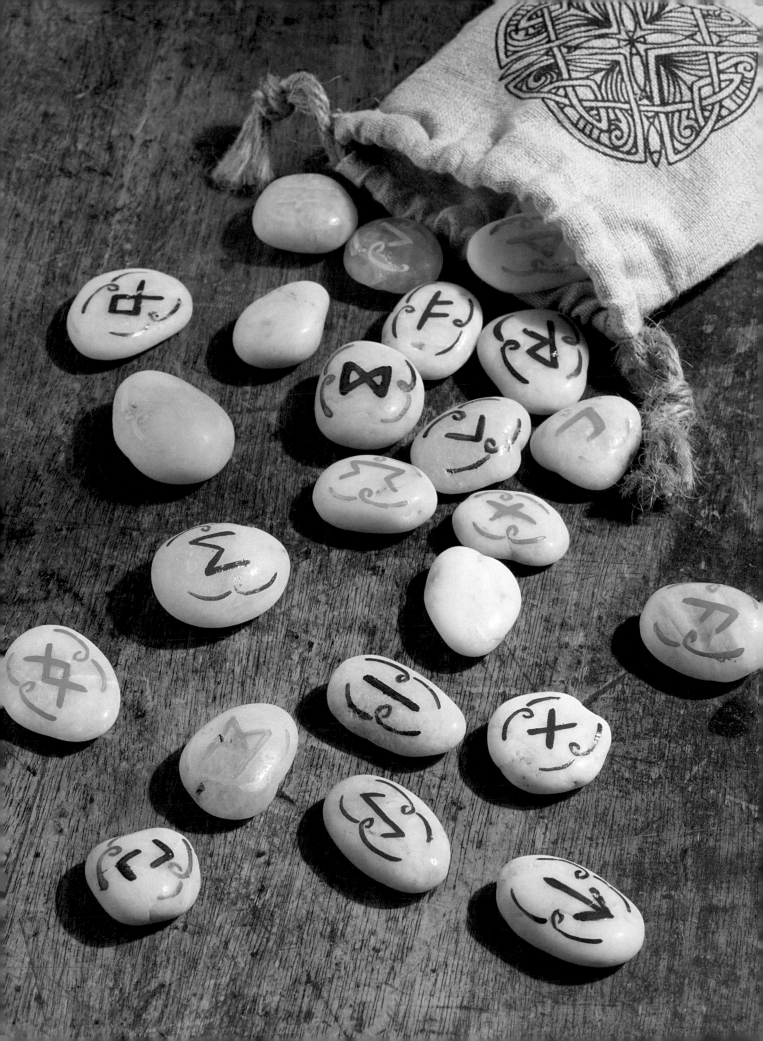

Templates

The following pages include some of the more complicated Celtic designs and decorations. Enlarge these templates to the size you require on a photocopier then trace and transfer them to your project, inserting your own lettering where necessary.

Celtic Jewelry Box, page 110

Uncial Place Card, page 64

Wishing Stone, page 40

Wooden Picture Frame, page
50 and Garden Seed Box,
page 104

Monogram Lampshade, page 86

Gaelic House-Blessing Card, page 46

Wooden Picture Frame, page 50

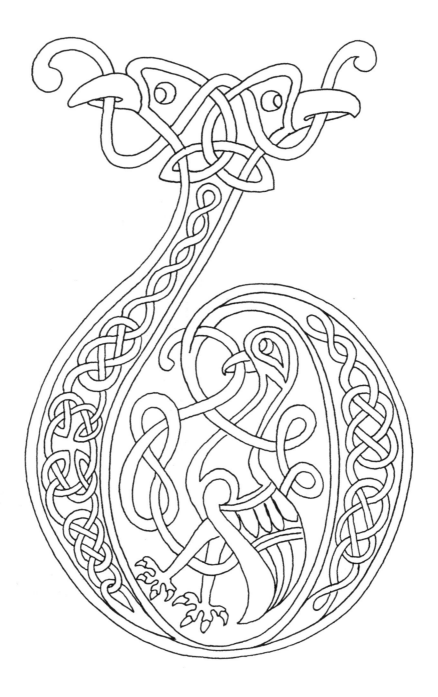

Zoomorphic Letter, page 94

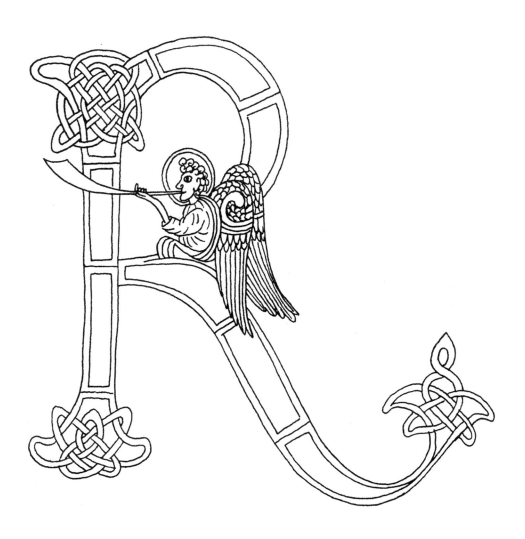

Illuminated Letter "R," page 56

Ceilidh Invitation, page 67

Chinese Proverb, page 82

Ex Libris Book Plate, page 80

Ceilidh Invitation, page 67

Name Plaque on Wood, page 42

Celtic Bookmark, page 78

Wooden Christening Plaque, page 90

Scottish Travel Blessing, page 52

Rainbow Alphabet Book, page 98

Anniversary Plaque, page 74

Slate Welcome Sign, page 70

Anniversary Plaque, page 74

Suppliers and Websites

Suppliers

Acorn Planet, Inc.
1091 Route 25A
Stony Brook, NY 11790
Fax: (631) 675-0496
http://www.acornplanet.com
Oriental brushes, inks and rice papers.

Blick Art Materials
Galesburg, IL 61402-1267
Toll-free tel: 1-800-828-4548
Tel: (309) 343-6181
Fax: (309) 343-5785
http://www.dickblick.com
Books and supplies. On-line shopping
and store locator.

Currys Artists Materials
2345 Stanfield Road, Suite 400
Mississauga, ON L4Y 3Y3
Toll-free tel: 1-800-268-2969
Tel: (416) 798-7983
Fax: (905) 272-0778
http://www.currys.com
General art and craft supplies.

DHP Papermill & Press
158 North Clinton Street
Poughkeepsie, NY 12601
Tel: (845) 454-8151
Fax: (845) 454-6429
http://www.dhproductions.net
Handmade paper and stationery.

Exaclair, Inc.
143 West 29th Street, Suite 1000
New York, NY 10001
Toll-free tel: 1-800-933-8595
Tel: (646) 473-1754
Fax: (646) 473-1422
http://www.exaclairinc.com
Specialist nibs and calligraphy papers.

J. Herbin
143 West 29th Street, Suite 1000
New York, NY 10001
Toll-free tel: 1-800-933-8595
Tel: (646) 473-1754
Fax: (646) 473-1422
http://www.jherbin.com
Handmade French and Italian inks, quills,
and reed and glass pens.

Ichiyo Art Center
1224 Converse Drive N.E.
Atlanta, GA 30324
Toll-free tel: 1-800-535-2263
Tel: (404) 233-1846
http://www.ichiyoart.com
Japanese calligraphy materials.

The Japanese Paper Place
887 Queen Street West
Toronto, ON M6J 1G5
Tel: (416) 703-0089
Fax: (416) 703-0163
http://www.japanesepaperplace.com
Japanese handmade papers.

Letter Arts Book Club, Inc.
John Neal Books
833 Spring Garden Street
Greensboro, NC 27403
Tel: (336) 272 6139
Toll-free tel: 1-800-348-PENS
Fax: (336) 272-9015
http://www.johnnealbooks.com
Books and supplies, including nibs for left-
handers.

Loomis Art Stores
Omer DeSerres
334 St-Catherine Street East
Montreal, QC H2X 1L7
Toll-free tel: 1-800-363-0318
Tel: (514) 842-6637
Toll-free fax: 1-800-565-1413
Fax: (514) 842-1413
http://www.loomisartstore.com
21 stores across Canada. Ships abroad.

New York Central Art Supply
62 Third Avenue
New York, NY 10003
Toll-free tel: 1-800-950-6111
Tel: (212) 473-7705
Fax: (212) 475-2513
http://www.nycentralart.com
Extensive selection of papers.

Opus Framing & Art Supplies
3445 Cornett Road
Vancouver, BC V5M 2H3
Toll-free tel: 1-800-663-6953
Tel: (604) 435-9991
Fax: (604) 435-9941
http://www.opusframing.com
Locations in Western Canada. Ships abroad.

Oriental Art Supply
21522 Surveyor Circle
Huntington Beach, CA 92646
Tel: (714) 969-4470
Fax: (714) 969-5897
http://www.orientalartsupply.com
Japanese and Chinese ink sticks and brushes.

Paper & Ink Arts
3 North 2nd Street
Woodsboro, MD 21798
Tel: (301) 898-7991
Fax: (301) 898-7994
http://www.paperinkarts.com
Vast selection of books and supplies.

Pendemonium
619 Avenue G
Fort Madison, IA 52627
Toll-free tel: 1-888-372-2050
Tel: (319) 372-0881
Fax: (319) 372-0882
http://www.pendemonium.com
Specialist in pens and inks.

Sepp Leaf Products, Inc.
381 Park Avenue South
New York, NY 10016
Toll-free tel: 1-800-971-SEPP
Tel: (212) 683-2840
Toll-free fax: 1-800-971-7377
Fax: (212) 725-0308
http://www.seppleaf.com
Traditional gold and metal leaf and
gilding supplies.

Websites

A search on the Internet will yield a vast
wealth of resources on calligraphy, from
classes and workshops to suppliers
and publications.

http://www.cynscribe.com
A good place to start your search is with
this online directory of more than 1,000
calligraphy links.

http://www.winsornewton.com
One of the most comprehensive ranges of
all types of calligraphy equipment, avail-
able worldwide.

http://www.tigon-crafts.co.uk
Information about the Celtic alphabets
from author Fiona Graham-Flynn.

Index

Acknowledgments

I would like to dedicate *The Simple Art of Celtic Calligraphy* to the following people: my dear husband, Christopher, whose constant love, patience, and support gave me the courage to write this book, to my parents John and Gwen Graham, who are with me in spirit and always believed in the talent I was given, to my dear son Sam and, lastly, my grandchildren, Lucy and Louis, who always show an interest in my calligraphy. I hope one day they may come to learn by it.

My thanks go to my uncle, Gerald Flynn, and friends in Limerick, for all their kind help with the Gaelic translations.

I would also like to say thank you to CICO Books for giving me the opportunity to write this book—it means so much to me.

Picture Credits

Page 6 (bottom): The Board of Trinity College, Dublin, Ireland/The Bridgeman Art Library
Page 7: British Library Board/The Bridgeman Art Library